PAINTING

PAINTING

JAMES OGILVIE-FORBES

Illustrated by
Dee McLean

Consultant
Kimberley Reynolds

Kingfisher Books

First published in hardcover in 1980.
This edition published in 1986 by Kingfisher Books Limited
Elsley Court, 20-22 Great Titchfield Street, London W1P 7AD
A Grisewood & Dempsey Company

BRITISH LIBRARY CATALOGUING IN PUBLICATION DATA
Ogilvie-Forbes, James
 Painting. – 2nd ed. – (A Kingfisher guide)
 1. Painting – Technique
 I. Title
 751.4 ND1500
 ISBN 0-86272-188-1

Edited by Christopher Tunney and Diane James

Printed and bound in Italy by
Vallardi Industrie Grafiche S.p.A. Milan

CONTENTS

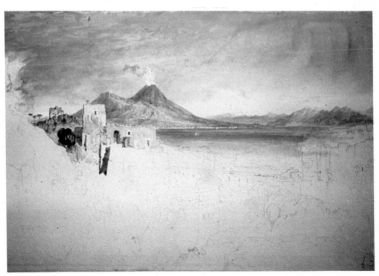

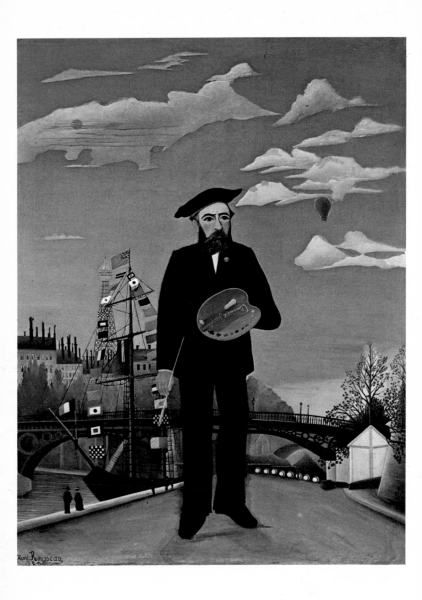

Introduction

Painting and drawing are often thought of as difficult or even daunting activities, only suited to the creative and artistic few and requiring long training. This is not the case; the beginner can achieve satisfactory and rewarding results almost immediately, and it is never too late to start! It is not necessary to be an accomplished draughtsman before tackling a painting, nor is it necessary to master complicated theories on perspective drawing. What does help the beginner is a basic knowledge of the various media available, how they are used, and what types of surfaces there are to paint or draw on.

Some people will prefer using water-colour, some oil-paint, and others will be happy with drawing in black and white using pencils, pen and ink, charcoal, or conté. A great deal depends on the temperament of the would-be artist, but nothing can be lost by experimenting with as many different media as possible.

Inspiration and encouragement can be gained by studying the Old Masters as well as paintings and drawings by popular artists from different periods in history. In this way, the beginner can see the problems that confronted the artist, and how these problems were overcome.

Left: Henri Rousseau: Myself, Landscape—Portrait.

Below: Vincent van Gogh: La Maison de Zandemennik *(Charcoal). In this early drawing, the rather clumsy handling of the charcoal and some of the detail shows that even the greatest artists experience the same difficulties as any beginner.*

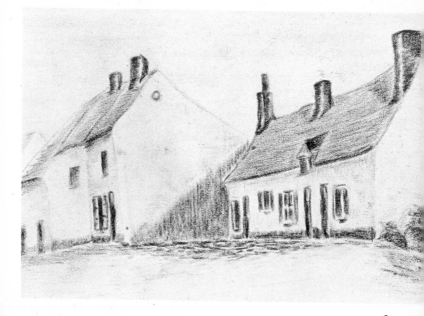

What Sort of Paints to Use

Many people begin painting because they are given a box of paints as a present. This settles the question of which kind of paint to use: the varieties of equipment, paints, and techniques can be bewildering to the beginner.

Of course, there is no reason why a painter should be limited to the use of only one sort of paint. Picasso and other famous artists used every conceivable kind of material, including many not normally found in an art shop. Ideally, beginners should choose the variety of paint best suited to the sort of painting they intend to produce.

The different varieties of paints,

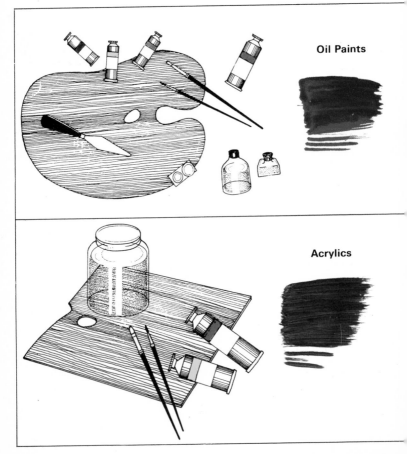

Oil Paints

Acrylics

chalks, and crayons are made by extracting colour from a wide range of substances. For example, ivory black is made from bones, and in the past artists even experimented with ground egg-shells for making white paint. Other paints are made from ores and earths.

The solid colouring matter, called *pigment*, is ground up finely and then mixed with something to bind it together. Water-colour is bound together with a glue such as gum arabic.

Without this binding it would crumble back into powder again once it was dry. Oil paint is bound with oil, and acrylic with an acrylic emulsion.

In the past, paints had to be prepared on the day they were used. The artist had to get up early in the morning so as to be ready for the day's painting. Later, they were kept moist in skins or bladders, and remained usable a little longer. Nowadays, the artist has few worries about his paints.

Oil paint is a pigment ground in an oil-based medium, such as a mixture of linseed oil and turpentine. It is probably the best type of paint for a beginner to use. The fundamentals of painting can be learnt more quickly by using oil paint than by using any other medium.

Oil paint is a sticky substance, and can take several days to dry, depending on how thickly it is used. For this reason, it can be difficult to control at first; but its slow-drying quality makes it capable of unlimited variety of use. It can be put on thickly with a brush or knife, or can be applied in almost transparent washes. It can be blended and modelled, and changes can easily be made by painting into the wet paint, or by scraping an area down with a knife and building it up again.

Acrylic paint is a recent development. It can be diluted with water and dried in a matter of minutes to a permanent state. However, there are ways of keeping it moist and it can be mixed with a variety of mediums to give different results—such as thick and shiny, transparent, or matt.

Painters who use large flat areas of colour and neatly painted edges find it ideal. It is particularly suitable for paintings that have been carefully planned in advance. But it is not always easy to use for outdoor painting unless a supply of water is readily available for washing brushes before the paint hardens.

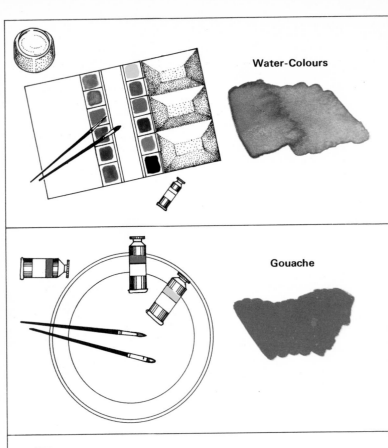

Water-Colours

Gouache

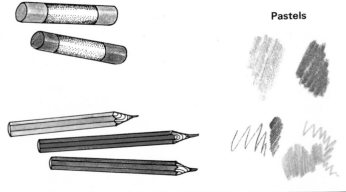

Pastels

Water-colour paint is often considered a difficult medium to use, because it is not easy to correct mistakes. The paint is applied thinly, and any fault is readily apparent. Unlike oil paint, water-colour cannot be scraped off; nor is it possible to start again without losing the freshness that is a vital quality of water-colour.

Water-colour is a medium that can be used in many ways, from a few washes of colour on top of an ink drawing, or a rapid note of a particular effect of light, to a fully-worked-out painting. Because the paints are compact and little equipment is needed, it is an ideal paint to use when travelling. Water-colour is excellent for landscapes but difficult to use for portraiture.

Gouache is a waterbound paint; it is really water-colour with white pigment added to it. The purpose of adding the white is to make the paint thicker and opaque, so that the paper does not show through. The paints commonly called *poster paints* are a form of gouache.

The best kind of paints to buy are called *Designer's Gouache Colours*. They can be diluted very thinly with water and used almost like water-colours; or they can be applied thickly and opaquely like oil paint. Gouache paints dry quickly and over-painting is possible. But the first layer of paint is easily disturbed, and the colours change slightly as they dry.

Pastels are made in two kinds—oil pastels and soft pastels. Oil pastels have only a limited range of colours, but because they can be used with linseed oil, colours can be blended. Soft pastels are made in many different colours and are more sensitive and subtle. They are slightly powdery and smudge easily, but their colour is very pure.

Both types of pastels are made in the form of sticks wrapped in paper. They respond readily to the grain of the paper. Special pastel papers are available in various colours.

Crayons, similar to the ones used by children, are very effective for making coloured drawings. There is a wide range of colours in the more expensive crayons, and it is possible to achieve a kind of blending and mixing by drawing little lines of different colours.

Black and White Drawing Materials

Practically anything that will make a mark can be used to draw with—from a ball-point pen to a chunk of burnt wood. Each drawing instrument has its own particular feel and quality, which to some extent will influence the finished drawing. Experimenting with different equipment may well inspire new ideas.

Pencils
Because the pencil is such a familiar object it is often underrated as a drawing instrument. However, the pencil is very versatile. It can make tough hard lines like a pen, or very soft areas of shading like conté or charcoal. Pencil marks have the advantage of being easy to erase.

Pencils are made in many degrees of softness and hardness. 9H is the hardest, HB is in the middle, and 9B is the softest. For general use, a B or 2B is quite adequate, but for drawings where a sharp line is needed a harder HB pencil is more suitable; the softer pencils lose their points quickly. The point of a B pencil may need sharpening every 15 minutes or so. A knife or razor blade provides the best means for sharpening points, as a pencil sharpener tends to eat up the wood before producing a point.

The clutch pencil—a fairly recent invention—takes replacement 'leads' of the same sort as are used in ordinary pencils; these are not made from lead, but from graphite. The clutch pencil has the advantage that the artist can keep the lead at a constant length. No sharpening is necessary as the leads can be advanced automatically. Ordinary pencils tend to break, get shorter as they are used, and become difficult to use when they are just stubs.

Any type of paper can be used for pencil drawings, but if many corrections or erasures are likely to be

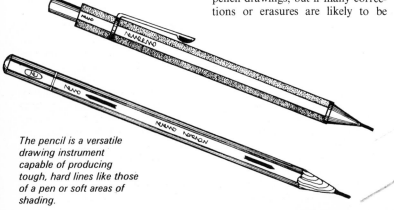

The pencil is a versatile drawing instrument capable of producing tough, hard lines like those of a pen or soft areas of shading.

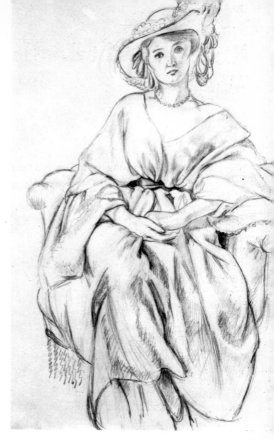

Henri Matisse: Seated Girl with Hat and Gown (Pencil). *The delicacy of this drawing shows what a sensitive instrument the pencil is. The way in which shoulder, arm, and drapery are depicted by variations of pressure on the pencil has a tenderness of line beyond the reach of pen or charcoal. The softer pencils are more aware of the grain of the paper, and result in a broader drawing. The harder pencils do not cover the paper so fluently; they cause the viewer to concentrate on specific areas.*

made, the tougher cartridge papers are best. Papers that have a rough surface, such as some of the watercolour papers, are ideal if a misty tonal quality is required.

Charcoal

Charcoal may be the oldest drawing material used by man. It is simply wood that has been burned in a special way. Today it is normally made from sticks of willow, and is sold in three sizes—thin, medium, and extra large. The extra large sticks are known as *scene painter's charcoal.* Charcoal can be bought in its natural state, or set in wood like a pencil. If a

sharp point is required, charcoal can be sharpened on a piece of fine sandpaper.

Beginners often find charcoal an imprecise and difficult material to draw with. It is messy and can crumble and break easily. But if it is used for large drawings—not less than A4 size—where the subject matter has plenty of contrasting light and dark areas, it will be found ideal for putting these in quickly and boldly. On the other hand, charcoal is not so well suited to small drawings where the outline is important. To avoid smudging an area that has been worked on, a piece of paper should

15

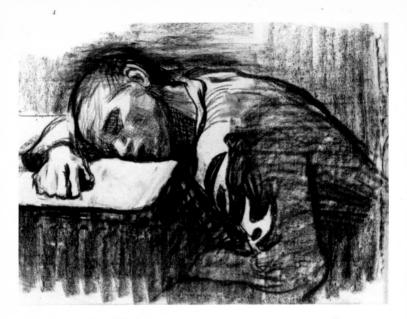

Käthe Kollwitz: Home Worker
(Charcoal). The dramatic contrasts of
dark and light and the way in which
the light seems to sculpt the figure
make this subject well-suited to
charcoal. Just as pencil expressed the
delicacy of the subject in Seated Girl
with Hat and Gown *by Matisse, so the*
fatigue and sadness of this figure are
conveyed by the harshness of the
stick of charcoal and the rough grain
of the paper.

Charcoal sticks

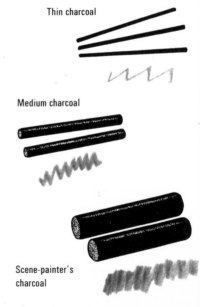

Thin charcoal

Medium charcoal

Scene-painter's
charcoal

be placed over this part before work
is continued.

Almost any paper, except very
shiny or thin paper, is suitable for
charcoal drawing. Cardboard and
brown wrapping paper are both
pleasant to work on. Some of the
grey pastel papers provide a good
background colour for the blackness
of the charcoal. Kneadable rubbers
—sometimes called 'putty' rubbers—
are useful for correcting mistakes,
and for lightening up particular areas.

Pen and Ink

Any sort of pen can be used to draw with, but the steel dip pen and the quill can make a greater range of marks than the ordinary fountain pen, the reservoir pen with a stylo nib, or the ball point pen.

Steel dip pens are usually sold complete with a reservoir, a nib-holder, and a set of nibs. There are many sorts of nib; the beginner may find the small mapping pen nib too scratchy, so a wider nib is more useful. If single nibs can be purchased, it is worth getting two or three different ones and trying them

out. Nibs should be carefully cleaned on a tissue after use, but if the ink does harden it can be scraped off with a small knife.

A calligrapher (fine lettering artist), often uses a reservoir attached to the pen nib, and this is essential for any fine work. Reservoirs come in two main types; one that clips underneath the nib, and the other which is part of the pen-holder and slides under the nib when it is attached. They enable the artist to continue drawing without having to keep dipping the nib into the ink. By keeping the flow of ink constant, the reservoir avoids

Pens *Some of the greatest pen drawings, such as those by Leonardo da Vinci and Michelangelo, were made with quill pens sharpened for italic writing: the nib produced a thick or a thin line depending on the angle at which the pen was held. By comparison, a consistent line—for example, that produced by a rapidograph—can seem dull.*

Charcoal *Thick sticks of charcoal are best for drawing in line without much shading. A point can be made by sharpening on fine sandpaper. The beginner may find that the sticks tend to snap, and may prefer to use short pieces.*

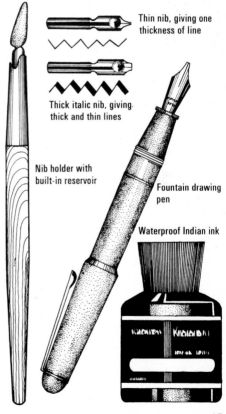

Thin nib, giving one thickness of line

Thick italic nib, giving thick and thin lines

Nib holder with built-in reservoir

Fountain drawing pen

Waterproof Indian ink

the blot-like effect of a freshly dipped nib and the scratchy mark made when a nib dries up. But sometimes this scratchy mark is used to create a special effect. The better qualities of ink usually have a stick built into the cap of the bottle. This is used for feeding the reservoir from the back, so that the nib need not be dipped directly into the bottle.

Good varieties of fountain-pen with flexible nibs for drawing are now available. Some of these take waterproof ink, and others take ordinary ink.

Inks. Waterproof Indian ink gives a very firm black line which will not run if colour is applied over it. If a less dense line is required, the Indian ink can be diluted with distilled water; non-waterproof ink can, of course, be diluted with ordinary water. Waterproof inks are made in a range of colours, and some of the brown shades blend well with washes of colour or diluted ink applied over them.

Papers. Soft papers may make the nib catch and splutter, so they should be avoided. Card that is not too shiny is useful, but any smooth writing paper or water-colour paper is adequate.

Conté

Conté crayons are made in Paris by the firm of Conté. They come in sticks about 7.5 cm long, or in pencil form. They are available in black, white, sanguine (a red earthy colour), and sepia (a darker brown). Conté is different from charcoal in that it is more compact, is slightly greasy, and responds sensitively to the grain of the paper that it is applied to. It is easier to control than charcoal, it can be sharpened to a point, and it

can be erased if it is used lightly.

Any type or colour of paper can be used with conté, and the conté will behave differently according to the surface of the paper. Because of this sensitivity, conté is particularly useful where careful areas of tone are needed. Some of the rougher water-colour papers with a definite 'tooth' are interesting to use, and the gentle colours of Ingres papers are ideal.

Rubbers

Rubbers—erasers—come in different shapes and sizes. A kneadable putty rubber is useful as it will not disturb the surface of the paper as much as a hard rubber. Rubbers should be kept clean. If they are carried around loose in a coat pocket, they can get greasy, and consequently make more dirty marks than they remove. A rubber should always be tested on a corner of the paper before it is used. In the same way, if a rubber is to be used to erase a large area of shading, it should be 'cleaned' from time to time on a corner of the paper.

Conté *Conté crayons are made in Paris by the firm of Conté in sticks of four colours: black, white, sanguine, and sepia.*

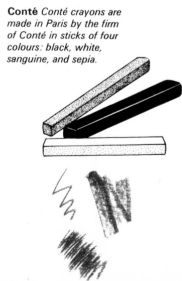

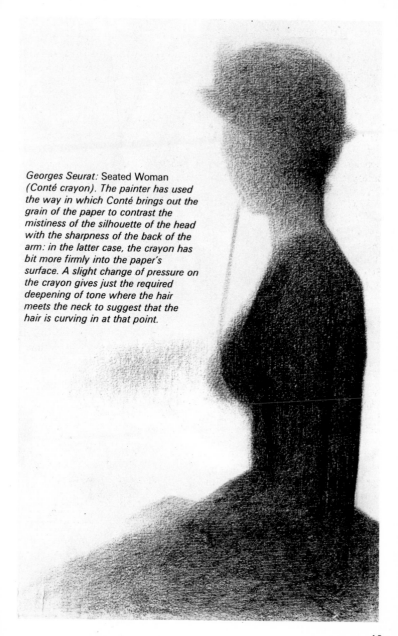

Georges Seurat: Seated Woman *(Conté crayon). The painter has used the way in which Conté brings out the grain of the paper to contrast the mistiness of the silhouette of the head with the sharpness of the back of the arm: in the latter case, the crayon has bit more firmly into the paper's surface. A slight change of pressure on the crayon gives just the required deepening of tone where the hair meets the neck to suggest that the hair is curving in at that point.*

Oil-Painting

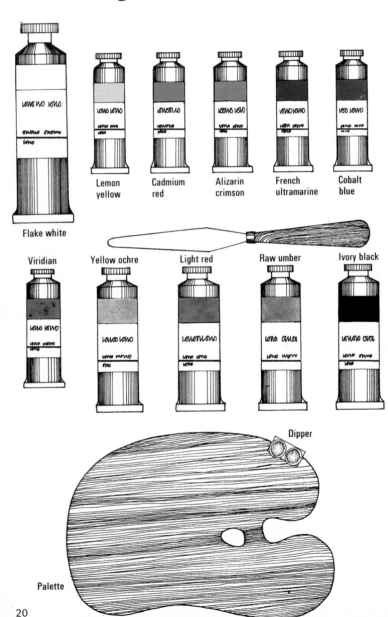

Flake white

Lemon yellow

Cadmium red

Alizarin crimson

French ultramarine

Cobalt blue

Viridian

Yellow ochre

Light red

Raw umber

Ivory black

Dipper

Palette

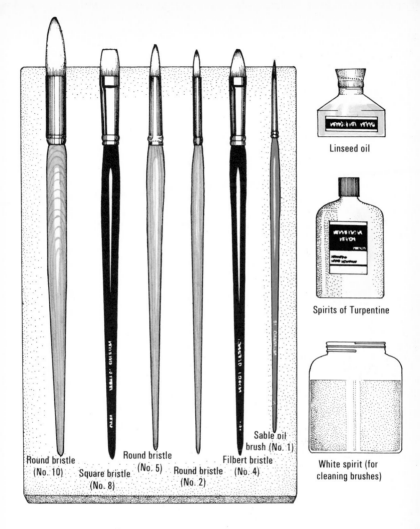

Round bristle
(No. 10)

Square bristle
(No. 8)

Round bristle
(No. 5)

Round bristle
(No. 2)

Filbert bristle
(No. 4)

Sable oil
brush (No. 1)

Linseed oil

Spirits of Turpentine

White spirit (for
cleaning brushes)

This check-list diagram shows nearly all the materials needed by the beginner in oil painting. The only items not shown are an easel and a container in which to carry the paints around. It is possible to buy boxes of paints already fitted with an adequate selection of paints and brushes. But it is probably better for the beginner to start with the items shown here until experience has been gained.

The list of colours shown in the diagram is a good range to start with. The advantage of beginning with a limited range is that the artist is forced to analyse and mix colours, rather than depend on a colour straight from a tube: this may look like the colour required but will probably not be accurate enough in practice.

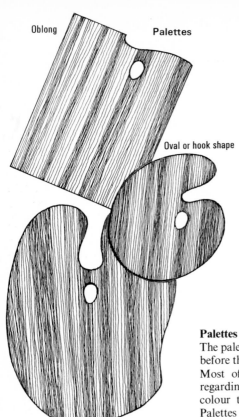

Oblong

Palettes

Oval or hook shape

Kidney or studio shape

The shape of the palette is a matter of personal preference. When the palette is held in the hand, it is important that the hole should fit the thumb comfortably and that the palette should be well balanced and not tiring to use. The oval palette is the most convenient for fitting into a box and for travelling. Many painters do not hold the palette, but rest it on a table or on the knees. This makes it possible to have a large palette; the larger it is, the more room there is for mixing colours. The palette must be kept clean: unused paint can be scraped off with a palette knife.

Palettes

The palette is used for mixing colours before they are applied to the canvas. Most of the hard decision-making regarding the choice of the right colour to use, comes at this stage. Palettes are made in three main shapes: the oblong, the hook, and the kidney or studio type. The most practical shape for travelling, painting outside, and storing, is the oblong.

Before buying a palette, it should be tested by holding it with a thumb through the hole, to make sure that it feels balanced and comfortable. The thumb hole can be widened, or can be adjusted for left-handed painters. This is done by sandpapering it until it feels comfortable. However, the palette does not have to be held in the hand—it can be rested on the knees, or placed on a nearby table. If the palette does not have to

Oil-paint is sold in different sizes of tubes, and different qualities. Some colours will come in for a lot of use, and others will hardly be used at all. So it is worth buying them in different quantities. The following colours can be purchased in the less expensive range: titanium white, yellow ochre, light red, alizarin crimson, and ivory black. The other colours should be bought in Artist's Quality. Although these are much more expensive, they are stronger in colour, more permanent, and in the long run more economical.

be held in work, then any piece of smooth wood can be used in its place. It must be made less porous by rubbing in a little linseed oil. A sheet of metal or glass will also make a good palette.

Palettes made of oil-proof paper are available; they come in pads, and each sheet is thrown away when it has been used once, leaving the next sheet ready. These disposable palettes tend to wrinkle and lift up and down when colours are being mixed, and when used outside they flap around in the wind. In any case, there is something much more pleasing and professional in using a good bit of wood to mix paints on. The palette must be large enough to give plenty of room to mix the colours needed.

The palette knife is for scraping paint off the palette at the end of the day. It can also be used for mixing colours. There are trowel-shaped palette knives and straight-bladed ones; either will do.

Brushes

It is worth spending more money on brushes than on any other piece of equipment. Good brushes will aid the beginner in the most important task—getting the paint in the right place. Cheap or worn brushes will prove useless.

Oil-painting brushes come in two main types. The soft-haired brushes are made of sable, and the stiffer bristle brushes are made from the hair of the hog. The latter are more useful to the beginner, but the choice, as with colours, is a very personal one. It is well worth spending time experimenting with different brushes. Sable brushes are useful for painting small areas, but if a beginner uses

this type of brush the work may well become too fussy.

Oil-painting brushes come in three shapes: round, filbert, and square. The round brushes give the widest variety of marks.

Mediums

A medium is a liquid used to dilute oil paint to make it the right consistency. But in many cases no medium is required and the paint can be used directly from the tube. In the early stages of an oil painting, when thinner paint is needed, a good quality turpentine can be mixed with the paint. A small amount of turpentine is put into a container, and the

Bristle brushes for use in oil painting are made in three basic shapes: round, filbert, and flat. It is a matter of feel which the painter likes best. The mark made by the square shape can seem repetitive, whereas the round brush is capable of a greater range of marks, and appears to have been the brush favoured by the Old Masters. Some artists use a selection of different shapes and sizes; others stick to a particular type and size. It is difficult to paint well with bad brushes: a good working rule is to spend more money on brushes than on any other items of equipment.

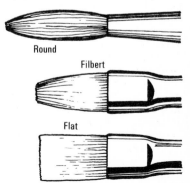

Round

Filbert

Flat

brush dipped into this from time to time. Later on in the painting, when thicker paint may be in use, a little bit of linseed oil can be mixed in with the turpentine to help maintain the brightness of the paint: one part of linseed oil should be added to two parts of turpentine.

Paint manufacturers also produce specially prepared mediums. These vary, and the details given on the label should be read carefully. If the details are not on the bottle they may be found in the manufacturer's catalogue. All mediums should be used sparingly; the paint should never be allowed to flow off the canvas.

The medium is kept in a little cup which can be clipped onto the edge of the palette. This is called a *dipper*. Dippers can be bought singly or as two joined together. The latter are useful if turpentine is to be kept in one and the medium in the other. Dippers can also be bought with screw-on tops. These are particularly useful when painting outside.

The contents of the dipper should never be used for cleaning brushes. Brushes should be cleaned in a jam-jar half-filled with white spirit or turpentine substitute. A good supply of cotton rag or tissue is essential for removing mistakes in the course of painting, and for cleaning up afterwards.

Easels
There are two main types of easels: solidly built ones for use inside, and lighter sketching easels which fold up and can be used indoors and outside. When painting outside, it is important to have an easel to keep the painting upright and steady. Most sketching easels have three legs: if

the weather is windy the legs can be pushed into the ground, or wedged with stones. A bag or weight suspended from the central part of the easel will also help to stop it from blowing over.

When painting inside, it is not so necessary to have an easel providing a table or chair is available to act as a prop for the painting. Or, the paper for painting can just be pinned to the wall.

Painting Boxes
Some sort of paint box is necessary when painting outside. The choice of box is very much a matter of what the artist can afford, and it is quite possible to keep all the equipment in a series of plastic bags or an old attaché-case. Some people find tool-boxes or boxes made for fishermen's tackle useful.

The paint manufacturers produce a range of special boxes. Some of these are sold empty and can be filled with the artist's own selection of paints and brushes. The most useful type has a lid that can be clipped into a vertical position. A small painting can then be propped against it instead of using an easel.

Most oil-painting boxes can be bought with an oblong palette that clips into the lid. This makes it much easier to carry all the equipment in one box.

What to Paint On
Canvas is very pleasant to paint on because of the texture of its woven surface. And because it has been stretched on a wooden frame—the *stretcher*—it has a certain taut feeling that seems to encourage the brush to do the right things. Canvas can be stretched and primed by the

artist or bought already prepared.

Unfortunately, canvas is expensive and the beginner is better advised to start with oil-painting boards. Specially prepared boards are sold in art shops. Some of these have primed canvas stuck to them, other cheaper boards have a surface that simulates canvas. Boards can also be made quite easily by painting thin hardboard with hardboard primer or oil-painting primer. The smooth side of the hardboard should be used and this should be lightly sand-papered before the primer is applied. Ordinary white household paint is not suitable for priming; it causes the painting to darken after a year or so. The artist may have to cut the hardboard to size. In this case a ruler and saw are needed.

Oil-painting paper is also pleasant to use, but it should not be rolled up as this makes it difficult to stick down satisfactorily. Once again, as with the choice of brushes and colours, the best surface to paint on is a very personal matter. Experimenting with a variety of materials is the only answer.

A sketching easel is adequate for most types of work—both landscape painting and painting indoors. It is best to have one that is not too complicated to erect, and that remains steady in use. Some easels have metal-spiked legs to prevent sliding around. Size can be important: if a painter likes to work standing, the easel must hold a board or canvas sufficiently high for comfort.

Board and Canvas Sizes

The following smaller sizes of board or canvas are particularly useful for landscape and still-life painting when the artist does not have time to paint a large picture. They are also easier to carry.

10 × 7 in (254 × 178 mm)
12 × 10 in (305 × 254 mm)
16 × 12 in (406 × 305 mm)
20 × 16 in (508 × 406 mm)
24 × 20 in (610 × 508 mm)

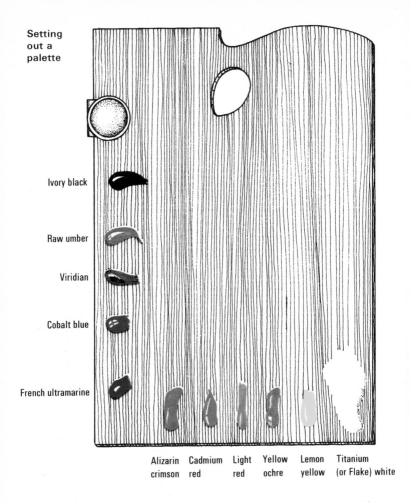

Setting out a palette

Ivory black

Raw umber

Viridian

Cobalt blue

French ultramarine

| Alizarin crimson | Cadmium red | Light red | Yellow ochre | Lemon yellow | Titanium (or Flake) white |

Making an Oil-Painting

The newcomer to oil-painting needs some basic information on the ways of tackling a painting. Later on, through experimentation, the beginner will develop personal ways of handling the paints and colours. Some artists stick to one definite procedure; others prefer the 'hit and miss' approach—more intuitive than scientific.

If paints are squeezed out onto the palette in the same order each time, mixing colours becomes easier and quicker. The painter soon learns, almost without thinking, where each colour is. There are many ways of setting out a palette. The way shown here keeps the lighter colours on one side of the palette, and the darker ones along the top. In this case, the lighter colours are also the warm colours—the reds, yellows, and ochres.

As a simple exercise in one method of procedure, the beginner should set up a still life of a green apple and an orange on a table. The oil paints should be squeezed out onto the palette in the order shown in the diagram. This arrangement places the colours from light to dark, and keeps similar colours together. There are other ways of arranging the paints, but it is important to choose one order and stick to it. In this way the artist knows exactly where each colour is, and time is not wasted in searching for a specific colour. This principle is the same one that typists and pianists use in getting to know the lay-out of their keyboards.

All the colours should be put onto the palette. It may look as though there is no blue or yellow ochre in the subject, but these may be needed for mixing another colour. White will be needed to lighten most of the colours, so more of this should be squeezed out than any of the other colours. A dipper containing some turpentine should be clipped to the edge of the palette—or be near to hand.

The board, or whatever is being used to paint on, should be set so that it is upright and firm. Of course, it is possible to work with the painting laid flat on a table or in the lap, but it is better both for the artist's back and for the painting if it is upright, and slightly to the left or right of the view of the fruit on the table. Having to peer round the board to see the subject can become annoying.

Most artists find it helpful to begin a painting by making an outline drawing, so that it is clear where the objects go. Even a simple subject— the apple and orange on the table— needs a preliminary drawing. This drawing will establish the relative size and position of each object, and also their position in relation to other things. A pencil can be used for the initial drawing, but in the long run it is more helpful to use a brush and diluted paint. By using this method, the artist immediately gets the feel of handling the brush, and will make a 'drawing' that is more linked to painting than if a pencil had been used.

One colour should be chosen for the initial drawing, and a small brush used—either a sable or a No. 1 bristle brush. Any colour will do,

Palette Knives and Painting Knives

A palette knife should always be used for mixing oil-paints on a palette. It is a much cleaner and neater way of mixing than using a brush, which will soon get clogged up and dirty. Palette knives are made of flexible steel with a wooden handle. They can also be used for scraping off any paint left on the palette at the end of a painting session. Apart from these uses, the palette knife can be used to apply paint to the board or canvas.

Special knives, known as painting knives, are available for applying paint; they are not suitable for mixing. They are made in various sizes with differently shaped blades: pear, trowel, and diamond shaped. If paint is applied to one edge of the blade, the knife can be used to make a fine straight line. Painting knives can also be used to cover large areas of a painting relatively quickly. All knives should be looked after carefully and always cleaned after use.

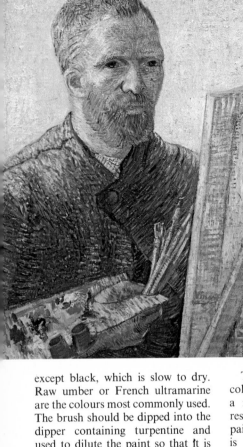

Left: Vincent van Gogh: Self-Portrait *(Oil). The portrait shows the way many painters hold palette and brushes. The gap between the thumb-hole and the nearest edge of the palette should not be too large for the brushes to fit comfortably in the hand. With practice, it becomes quite possible to hold a fistful of brushes as van Gogh is doing here, and it is more convenient than leaving them on a table or standing them in a jar.*

Right: Walter Sickert: The Servant of Abraham *(Oil). If this painting is compared with the one on the left, it will be seen that Sickert uses large areas of colour that fit together almost like a jigsaw puzzle, whereas van Gogh handles his paint in small touches of colour.*

except black, which is slow to dry. Raw umber or French ultramarine are the colours most commonly used. The brush should be dipped into the dipper containing turpentine and used to dilute the paint so that it is quite wet and thin when it is put on the board. A time limit should be set for the drawing—no longer than half an hour. It may not take this long, but it should certainly not take any longer. When the initial drawing is finished, the artist can see exactly where the fruit will be, and at this stage should make a mental note of where some of the different colours begin and end.

The next stage is to mix up the colours. If the colours are applied in a random way, a mess will soon result! It is possible to scrape oil-paint off and change colours, but it is better to start the painting in a methodical way.

The artist should select one specific area of the painting—preferably one where two or three colours meet. A suitable spot would be the one where the apple, orange, and table are all touching each other. The green apple might perhaps be tackled first, in particular the right-hand side of it, where it is slightly darker.

The artist now faces the problem

of how to mix the right colours. A careful study should be made of the palette, and the colour nearest to the green of the apple selected. Some of this colour is picked up with the palette knife and put down in the middle of the palette. Is it too dark? Or too light? The addition of some yellow may help, but if this makes the green too lurid, some white may then be necessary. The artist should continue to add and mix colours until the resulting colour is as close to that of the object as possible.

The artist can now start painting. A small amount of green is applied to the side of the apple, but the whole apple should not be painted at this stage. The orange can be tackled next. The palette knife should be cleaned on a rag or piece of tissue. A little bit of lemon yellow is put on

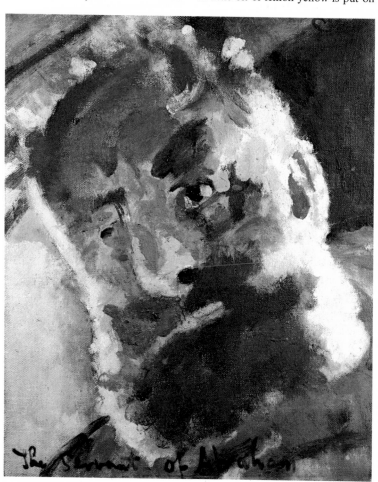

The Servant of Abraham

the tip of the knife and placed near the mixture for the green apple. A bit of cadmium red is then mixed thoroughly with the yellow. Once again the result may be too bright. Too much of the lemon yellow may have been used, in which case the colour will be a yellowy-orange, so more red should be added.

The colour for the table should be mixed next; this may prove more difficult. When it is satisfactory, it is applied to the painting next to the apple and the orange. Once again a new brush should be used.

The artist now has three colours working together, and can see the effect they have on each other. Sometimes an artist puts down a colour that looks right on the palette, but when another colour is placed beside it on the painting, the whole effect may be altered. It is necessary to be constantly aware of adjoining colours.

The artist can now branch out to other parts of the painting. Another area should be chosen where there are three or four different colours— for example, the wall behind the apple and orange. The colours should be mixed using the same method as before. The original green, orange, and table colours should be left on the palette as they will be needed

later when the artist goes back to do further work on that particular area. By the time several colours have been mixed it becomes clear why it is essential to have as large a palette as possible.

The painting should be continued by building up patches of colour: often beginners are tempted to start at the top and work downwards! Some artists use small touches of the

Paul Cézanne: Still Life *(Oil). This unfinished painting offers an opportunity of examining the way in which Cézanne worked. It can be seen how the picture grew, not following any formula or rules but trying to explore with paint what was there in reality.*

brush to build up areas of colour, but others use large blocks of colour. The beginner will soon discover his own most suitable and effective way of painting.

Studying Paintings

The oil-painting on this page by Cézanne is unfinished. Because of this it is possible to work out how Cézanne approached the subject. It is clear that he used a very diluted blue colour for the initial drawing. The subject is complex and because of the number of objects in it, it would not be a suitable one for a beginner to tackle. But if just one part of this painting is studied in detail, a great deal can be learnt about Cézanne's method of painting.

Firstly, the colours are all clean and bright. This is achieved by using

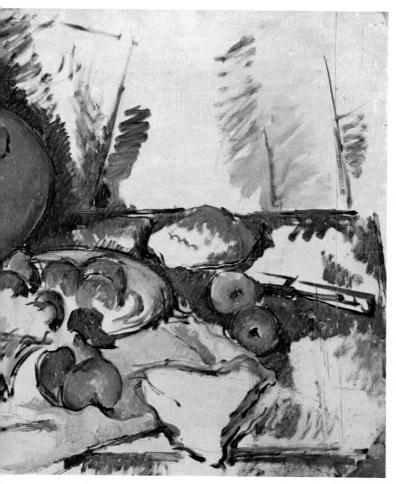

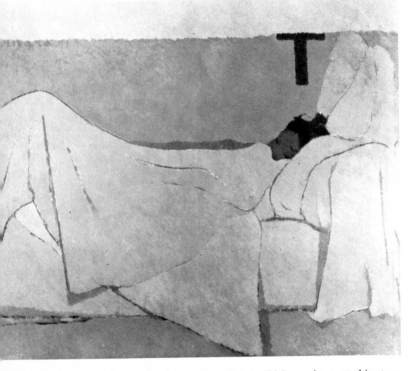

a different brush for each mixture of colour—a good reason for having a number of brushes. Cézanne may well have used between 30 and 40 brushes in one session of painting. Another way of keeping the colours clean is by spending time and taking great care when mixing colours. The colours should not be allowed to get muddled up on the palette.

It is also useful to analyse the way in which Cézanne builds up the painting; using touches of quite thin paint, sometimes rubbing in an area to get it covered, at other times applying the colour more thickly. The old rule, which is technically very sound, is to start with lean paint, and as the painting is built up to use slightly thicker colour; at this stage a little linseed oil should be mixed with the turpentine.

If the paint seems to go down on the board efficiently, there is no need to add any medium. Oil-paint should never be as thin or as transparent as water-colour, because its colour and substance do not register if it is used thinly. Cézanne's method of using small touches of paint to build up whole areas requires a good deal of patience and time.

An alternative method is to paint in larger areas. In the painting by Edouard Vuillard titled *In Bed*, the artist has mixed up the colour for the large area of the wall, the colour for the bed, the colour for the floor, and

the colour for the shadows on the pillow and sheets. These colours have then been put down in quite simple, distinct areas. When using this approach, it is better to spend more time on mixing the colours than on actually applying them to the painting.

Brushmarks

The painter should not worry about which way the brushmarks are going. The beginner should experiment with a variety of techniques for laying colour down. It can be scrubbed in quickly or applied carefully to an edge. The painter's foremost thought

should be where a particular patch of colour is to be put. Any way of getting this colour down will do—a finger, a paint brush, or a palette knife are all acceptable.

Painting One Edge of Paint Against Another

When one area of paint has been put down and another colour has to be painted beside it, the artist may find it difficult to avoid getting the colours mixed up with one another. It is this sort of messiness that puts some people off using oil-paint, and causes the beginner to get the colours muddy. But with a little experience the problem can be overcome.

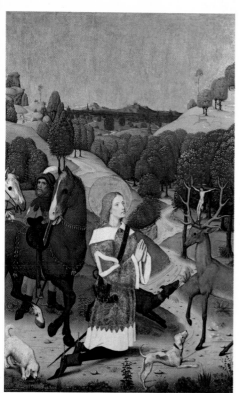

Far left: Edouard Vuillard: Au Lit *(Oil). Unlike Cézanne's painting, which uses many small brush marks and observations of changes of colour, Vuillard's painting is built in larger and flatter colour areas. The paint is not as thin as that of the unfinished Cézanne; it is applied as an opaque paste of colour. The beginner can learn much from applying the paint in flat areas of colour as Vuillard has done here.*

Left: The Master of the Life of the Virgin: The Conversion of St. Hubert *(Oil on panel). This luminous work is quite different from the other paintings shown in this section. It was built up— perhaps over a period of years—starting with an elaborate drawing, modelled with darks and lights, and finally coloured in layers.*

If a light colour is applied next to a dark colour, and some of the dark paint gets caught up with the light one, there is no need to panic. The brush can be cleaned on a rag, dipped into more of the light colour on the palette, and the problem patch painted over again. It is always useful to have the dark colour on one brush and the light colour on another. This means that both edges of the join can be painted without wasting time cleaning the brush. Of course, if the painter makes a mistake with the light colour and it goes over the edge into the dark area, the error can be corrected very simply by covering the light mark with the darker paint. This method is called 'painting wet into wet', and can be of great use when painting rapidly.

Making Corrections
Oil-paint is unique because of the ease with which things can be changed during the course of painting, and mistakes corrected with a minimum of fuss. To correct a mistake, the palette knife is used to scrape off the paint—down to canvas level. Then a rag or tissue is dipped in turpentine and used to scrub away at the area where the paint was until it is quite clean. The area can then be repainted. Smaller mistakes can usually be corrected by painting on top of them using slightly thicker paint.

Using Black Paint
Black can be a very beautiful colour, but most of the time it is used merely as a darkening agent. If something to be painted is dark or in shadow, the beginner will all too readily add black to make what he thinks is the correct colour. Sometimes black is

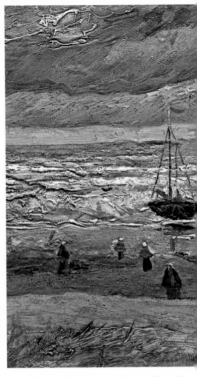

the right colour to use, but often it makes other colours look dirty or too muddy.

Raw umber and some of the other brown colours can often be used more successfully to mix a colour to a darker shade. If the painter looks hard at the colours of the shadows, there may be another colour on the palette that would do better than black. If there is an area in the painting that is definitely black, it should be studied carefully to discover what sort of black it is—it may be slightly brown or may need a touch of red added. Black paint nearly always needs modifying slightly and is seldom used straight from the tube.

Vincent van Gogh: Beach at Scheveningen *(Oil). This early painting of van Gogh demonstrates the difficulty beginners often have when applying fresh colours against an area that is still wet. The edges become muddy and perhaps unmanageable. The technique of controlling the painting is called 'painting wet into wet'. The brush should be well loaded, and the painting done confidently. As soon as the brush begins to pick up the wet paint underneath, it should be cleaned and recharged.*

Cleaning Up After Painting

All the paint that has been mixed in the central part of the palette should be scraped off with a palette knife, and can then be wiped off the knife onto a tissue or a piece of newspaper. If the painting is to be continued the following day, the colours that were squeezed from the tubes around the edge of the palette can be left. But if no more painting is to be done for some time, these paints must be removed too. If there is a fair amount of one colour left, it can be kept in an air-tight jar.

When most of the paint has been removed, the palette should be cleaned with a rag and white spirit. Wooden palettes should be finished off by rubbing with a little linseed oil, leaving them clean and shiny. The linseed oil keeps the wood clean and fresh. Paint should never be allowed to harden on the palette. If this does happen, the next time the palette is used to mix paint the surface will be bumpy; and the colours of the dried paints cause confusion when new colours are mixed on top.

Brushes should be wiped on a rag or tissue, and then rinsed thoroughly in white spirit. If they are to be used the following day, they can be left at this stage, but if they are not to be used again they should be washed carefully with soap and water. A bar of any white soap is adequate for this. Each brush should be rubbed into

Oil-Painting Do's and Don't's

DO use a different brush for each mixture of colour. The beginner may not have enough brushes to start with to make this possible; in this case, when another colour is needed, the brush should be wiped on a cloth, rinsed in a jar of white spirit, and dried out before the new colour is used.

DO hold the brush some distance up the handle—away from the bristles and the ferrule. Oil-painting brushes have long handles to enable the artist to be at some distance from the painting. If the artist gets too near his work, he will tend to fiddle and to apply small areas of colour. This method is only suitable if the artist has several weeks in which to build up the work.

DO get the paint on the end of the bristles so that it is not caught up around the ferrule. The brush should be wiped through from time to time on a rag.

DO mix enough paint to complete a particular area—for example, a large area of sky or a background colour. If the paint runs out half way through a painting, it can be difficult to mix the same tone again.

DON'T use up paint in the later stages of a painting just because it has been left over. Many good paintings in which the colours have been carefully observed and mixed initially are subsequently spoilt by the artist trying to get rid of what is left on his palette. It is much better to waste a small amount of paint than to spoil a painting—if there is a reasonable amount of paint left it can be stored in an airtight jar.

DON'T let the medium in the dipper get too dirty before changing it. The medium should never be used for cleaning brushes as this will make any subsequent colours very muddy.

DON'T varnish an oil-painting too soon. It is not absolutely essential to do so at all, but the varnish does give the painting a protective layer; although this may yellow in time. It takes between three and six months for a painting to dry thoroughly, and if the paint is very thick it can even take as long as nine months. The varnish should be applied in a thin even layer, either with a large brush or an aerosol can of varnish.

the soap; a great deal of paint will come out, especially round the ferrule. This is where the paint tends to collect and harden, so it is advisable to work hard at the soap and water. The brush should be rinsed occasionally in warm (not hot) water, until there is no more trace of colour. Then it can be dried on a towel and licked into shape, so that the bristles come to a point. If a good brush is well cared for in this way, it will last for several years.

Brushes left standing in a jar or pot look decorative and artistic, but if they are not used frequently, it is the worst possible way to store them. Dust can fall between the bristles, and gravity makes the hairs bend outwards. The best way to store

brushes is to have them lying flat.

Turpentine should be stored in a dark place—the paint box is ideal. Linseed oil should be kept near a window with some sunlight. If oil-paints are not going to be used for some time, it is important to make sure that all the caps are on the tubes, or the paints will harden.

Varnishing the Painting

Oil-paint takes quite a long time to dry. It may seem dry to the touch after a few days, depending on how thickly it was applied. But underneath it does not dry out for about a year. It is important to leave this length of time before the painting is varnished.

The purpose of the varnish is to protect the painting from dust and the harmful effects of smoke and pollution. Several types of varnish are made, and instructions for use are usually on the side of the bottle. Some varnishes are available in aerosol form.

It is important when varnishing a painting to make sure that it is not dusty; and if the varnish is to be applied with a brush, this too must be absolutely clean and dry. The painting can be dusted gently with a damp cloth the day before varnishing.

Great care must be taken not to apply too much varnish, or an uneven coverage will result. The painting should be lying flat so that the varnish does not run.

The varnish should not be scrubbed on, or it will leave little air bubbles behind. It should be applied with clean strokes of the brush and then left alone. Varnishes vary in shininess, and some matt varnishes are available; these have no shine at all.

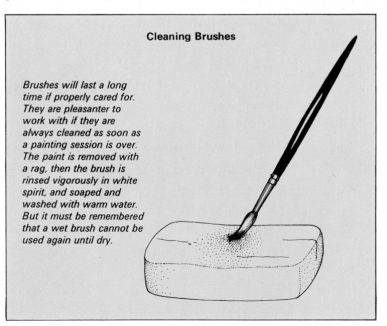

Cleaning Brushes

Brushes will last a long time if properly cared for. They are pleasanter to work with if they are always cleaned as soon as a painting session is over. The paint is removed with a rag, then the brush is rinsed vigorously in white spirit, and soaped and washed with warm water. But it must be remembered that a wet brush cannot be used again until dry.

Water-Colour Painting

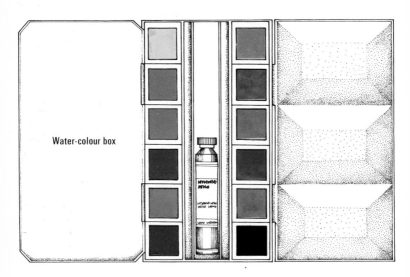

Water-colour box

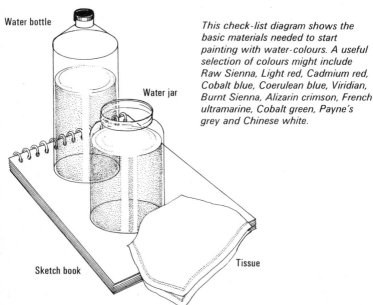

Water bottle

Water jar

This check-list diagram shows the basic materials needed to start painting with water-colours. A useful selection of colours might include Raw Sienna, Light red, Cadmium red, Cobalt blue, Coerulean blue, Viridian, Burnt Sienna, Alizarin crimson, French ultramarine, Cobalt green, Payne's grey and Chinese white.

Sketch book

Tissue

Water-colour paint is made in two forms—tubes and pans—and it is a matter of personal choice which to use. The tubes tend to harden in time and so they are not advisable unless they are used frequently. Water-colour pans are made in two sizes—half-pans and whole-pans. Most

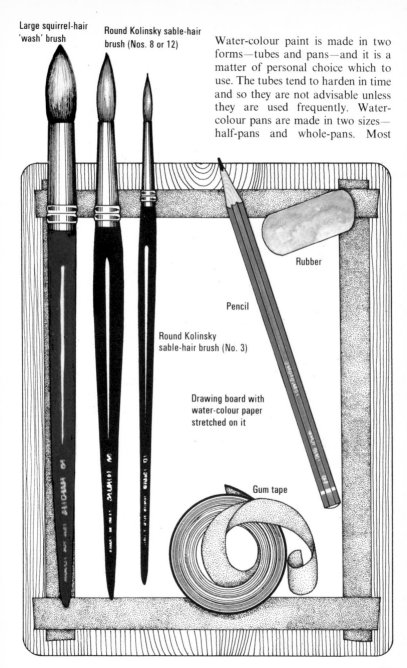

Large squirrel-hair 'wash' brush

Round Kolinsky sable-hair brush (Nos. 8 or 12)

Rubber

Pencil

Round Kolinsky sable-hair brush (No. 3)

Drawing board with water-colour paper stretched on it

Gum tape

J.M.W. Turner: View of Venice from the Lagoon *(Pen, chalk, and water-colour over a pencil sketch). Turner used water-colour in many different ways and on paper of various colours. Sometimes, he would prepare his own paper with washes of warm browns, light greys, or greenish blues. The freedom of this painting is deceptive, because Turner was trained in the meticulous art of topographical painting—depicting architecture and popular views. His generalizations are based on a profound knowledge of detail.*

painters find the half-pan adequate. They are also made in two qualities. The more expensive is called *artist's quality*. It has the advantage that the colours last a long time.

The Water-Colour Box
This box, designed for holding either pans or tubes of colour, also provides a mixing surface. The larger the painting to be undertaken, the larger the box will have to be, so that enough paint can be mixed at one time.

Water-colour boxes vary a lot in price. A box can be bought empty so that it can be filled with the painter's own selection of pans or tubes; these can be bought separately. Sometimes a box has a metal ring underneath that slips over the painter's thumb. The box can then easily be held in one hand, leaving the other hand completely free.

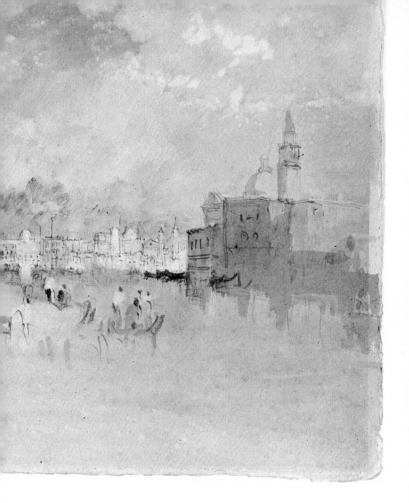

The Brushes

The best water-colour brushes are made of hairs from the tail of the sable. The hair is soft but keeps its shape firmly. Sable brushes are very expensive, but it is worth having at least one of them. Artists usually think more about brushes than other pieces of equipment—the choice tends to be very personal. A brush that suits one person may prove unusable to another.

If a large area of a painting is to be covered by a wash, then a wash brush is needed. Some people prefer using bristle brushes, which means that the paint is, in effect, scrubbed onto the paper.

One good-quality brush is adequate for the beginner, but every opportunity should be taken to experiment with different sizes. It is useless buying cheap water-colour brushes, as they will wear out quickly.

41

Other Equipment

A tissue or rag is essential, and when painting out of doors, a good supply of clean water should be taken. Some artists use an easel to support the drawing board, but this is not really necessary as it is possible to sit on a comfortable chair or camping stool with the board propped up in the lap.

The Paper

A wide selection of water-colour papers is available. Some are rough, some thick, and some coloured. They are made in blocks and in pads; larger art shops will stock loose sheets. Good water-colour paper is expensive, and it is not advisable to buy an expensive block of a particular paper unless it has been experimented with beforehand.

It is quite possible to use any kind of paper, as long as it is not shiny.

A good cartridge paper is suitable for a beginner. The problem with cartridge paper and other thinner paper is that it tends to buckle and wrinkle when water is applied to it. To avoid this happening, the paper is prepared for water-colour painting by stretching it.

Preparing the Paper

A sheet of clean white cartridge paper is needed in addition to the piece to be stretched. Also required is a roll of gummed brown paper—not masking tape, or Sellotape, but the type that can be moistened and is normally used for doing up parcels; a pair of scissors; and a drawing board, or any piece of hardboard that is larger than the paper to be stretched.

The preparation process is best carried out in a room with a sink, such as a bathroom or a kitchen. The piece of paper should be placed in a basin of cold water. Thinner papers will need a quick dip to make sure both sides are wet, but the heavier papers may need a bit more

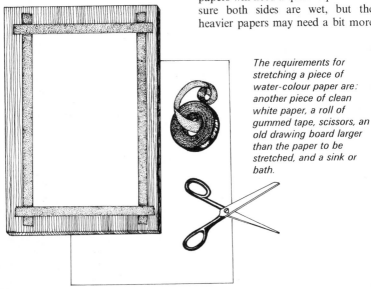

The requirements for stretching a piece of water-colour paper are: another piece of clean white paper, a roll of gummed tape, scissors, an old drawing board larger than the paper to be stretched, and a sink or bath.

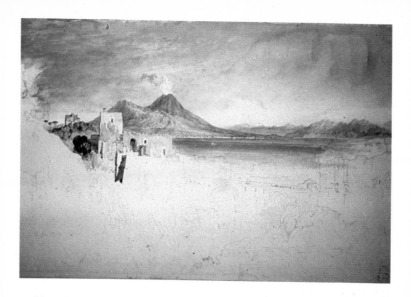

soaking. The paper is removed from the sink, with one corner held in each hand, and it is then laid on the drawing board.

Then the sheet of clean white cartridge paper is put on top, and carefully smoothed over with a handkerchief or cloth—working towards the edges. The top sheet of paper is then removed, with care being taken not to lift up the wet sheet underneath. Four strips of gummed paper are cut to size and stuck around the wet paper to secure it to the board. At this stage, the wet paper must not be touched or dabbed because it must be allowed to dry evenly. The board should be left lying for at least half-an-hour—not near any direct heat.

The paper can be used as soon as it is dry. When the painting is finished, the paper can be cut off the board with a knife. If a painter is going to spend a whole day painting, it is worth while preparing several pieces of paper on one board.

J.M.W. Turner: View of Naples Looking Towards Vesuvius *(Watercolour and pencil). The careful preparatory drawing is evident in this unfinished work. It is more than a mere tinted drawing, for when Turner starts to apply the paint, the colour takes over. Quite early on, Turner developed a method—in addition to laying-on washes of colour—of building up a painting by a series of small brush strokes—little streaks and lines of differing hues. The result was a beautiful play of colour, and was a closer way of representing the depth of colour in the atmosphere.*

Method

Water-colour painting differs from the other media because the artist uses the whiteness of the paper to achieve mixtures of colour, rather than depending on the use of white paint. It is because of its transparency that water-colour is capable of producing a certain richness and beauty of colour that is impossible to achieve

43

with any other paint. In the past, water-colour was often used for landscape painting. Although any subject can be painted in water-colour, it lends itself to paintings requiring atmosphere and effects of light because of its subtlety and transparency.

Water-colour is a difficult medium to use because it is nearly impossible to change things when they have gone wrong. If a colour has been made too dark, for example, little can be done to change it without disturbing the surface of the paper, and making any subsequent colour lose its freshness. The beginner must therefore accept two things from the start. Firstly, there will be a high casualty rate—probably only three out of ten paintings will 'work' in a technical sense, so the more paintings that are attempted the better. Secondly, drawing plays an important part in water-colour painting, in the sense of getting things in the right place and

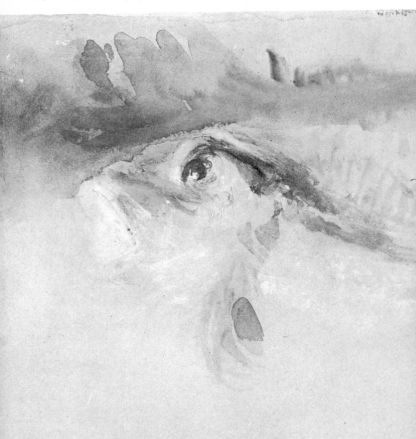

at the right size. Many water-colour paintings depend on a clean, accurate line-drawing underneath. When a pencil drawing is not used to start with, and colour is applied straight away, it is even more important to put the colours in the right place.

There are three main ways of going about water-colour painting, but of course there are many variations and combinations of these approaches. One method is to start with a careful drawing in pencil, or pen and water-proof ink. A few washes of light colour are then put over the drawing. The result does not depend so much on the colour as on the drawing, which shows through very clearly. This approach is similar to that of a children's colouring book: once the initial drawing has been done, the application of colour is almost routine. This method is a good introduction to using water-colour as it requires practice in putting on large smooth washes. The painter can con-

J.M.W. Turner: Study of a Gurnard *(Water-colour and body colour). Here, Turner seems to have used a minimum of preparatory drawing, if any at all. The fish is described beautifully by the placing of washes and dots and dribbles of the brush. This type of painting calls for courage and experience; but even the complete beginner should try rapid studies of this kind, however disastrous the results may be. The exercise will teach that painting is a matter of manoeuvring colours around—not just filling-in lines.*

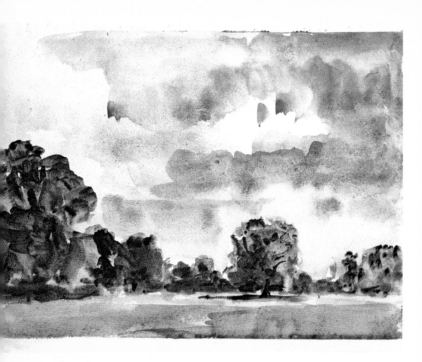

centrate on this rather than bothering about where the paint is going.

The second method is to begin with a drawing using pencil or charcoal, or a brush with one very diluted colour. This time there is no attempt to make such a detailed drawing as before, but more is left to the application of colour. When the work is completed the original drawing may well be covered. In this type of watercolour painting, the brush is much more important.

The third approach requires no preparatory drawing at all. Paint is applied straight-away with the brush. Washes of colour are also applied directly. This is a traditional Chinese method of painting, and it demands great concentration. It is particularly useful for painting views that are constantly changing. Both Turner and Constable used this method to note the colours of sunsets and clouds.

Water-colour, of all the painting media, is perhaps, the most elusive, and it is pointless to adopt too rigid a method of working. It is not necessarily a quick medium. Many watercolour paintings take weeks or months to complete. When a particular area of paint is being put down it is necessary to work fast—all methods and rules are blown to the wind. That is why there are so many alternative ways of working. Some artists begin by putting a few blocks of colour down. These are then drawn over before more colour is added. Others start by laying large washes across the paper.

Philip Wilson Steer: Haresfoot Park, near Berkhampstead Park, Hertfordshire *(Water-colour). This sketch clearly shows the 'wateriness' of water-colour painting. Skies and moods can sometimes be expressed beautifully by allowing colours to run into each other in puddles of wet paint.*

The only eye-witness to have observed the way in which Turner worked, recalled that he seemed to swamp the paper with water and scratch and dab at it; the result was a very accurately observed scene of two ships. Perhaps the best way for the beginner to start is by making a drawing, which is then built up using simple washes. As confidence in the handling of the paint grows, so more direct methods can be attempted.

Putting on a Water-Colour Wash

Sometimes there are large areas in a painting to be covered in one colour. It is a great advantage to a painter to be able to put on a smooth wash of colour that does not look blemished or broken. A good method for practising this is to draw a rectangle 25 cm × 15 cm, in pencil, on the paper to be used. Using a wash brush or a No. 8 sable brush, the painter drips clean water into one of the mixing pans in the paint box. The rectangle gives quite a large area to cover, and so quite a lot of water should be put into the pan. Any colour can be mixed with the water, but the result should be quite a strong mixture—well stirred up.

The board or block of paper on which the rectangle has been drawn should be tilted at a slight angle, and the brush well charged with the watery paint mixture. The painter then 'strikes' in the colour in bands across the rectangle, starting at the top and working down band by band. He takes care not to go back over any part already painted. Because of the tilt of the board, a river of watery paint will form along the bottom of each band as it is painted. This river must be caught up with the brush as quickly and calmly as possible as the next band of colour is applied. The process is continued working down the rectangle, moving across the page and always in the same direction— from left to right if the painter is right-handed.

Whenever the river of paint runs dry the brush should be re-charged and the process continued. When the bottom of the rectangle is reached, the brush should be dried on a tissue. The paint is allowed to dry for a few moments, and then the brush used to collect up any paint left at the bottom. This process may need to be repeated twice.

Because the paint is being put on in a wet state, the colour will be flooded on in a uniform way. If the colour was applied in a drier state the result would be streaky and uneven.

A colour wash is applied in exactly the same way when a smaller shape has to be filled. A good way of practising is to draw some irregularly-shaped outlines by tracing round such objects as keys or twigs. These outlined shapes can then be filled in with a wash. Once again, the board should remain tilted all the time.

Once a wash has been put down, it must be allowed to dry before another colour is put on top, or another wash laid beside it. If the wash is still wet, the colours will run together. Occasionally, this effect is exactly what is required—for example, when

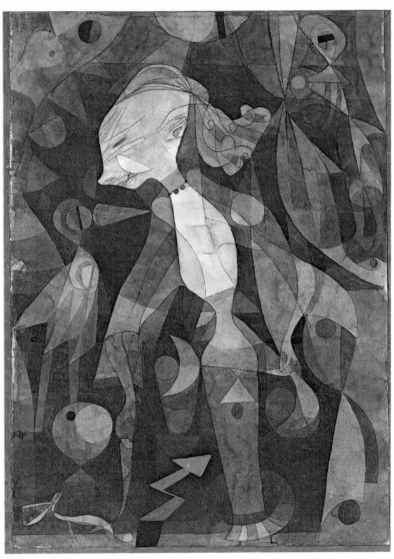

Paul Klee: Young Girl's Adventure
*(Water-colour). Water-colour is
sometimes thought of as a useful
medium for a quick sketch of a
favourite view or for making a study
for an oil painting, but not as a serious*
*medium in its own right. But in this
painting, only water-colour could have
achieved the subtlety that results from
the ability to lay one colour under
another in such a way that it will
shine through only in some places.*

the sky changes very softly from a blue colour to a golden warm colour. There are many tricks and effects to be obtained by using water-colour this way, but in most cases they should be avoided as they can lead to an artificial way of painting.

Working from Light to Dark

As a general rule when painting, the lighter colours should be applied first. If the foliage of a tree is light in some parts and in shadow and darkness in other parts, the whole tree should first be covered in the lighter colour. When that is dry, the colour of the shadows can be added on top. The advantage of this method is that it is easier to judge exactly how dark the darker shadows will be when some of the lighter colours have been put down. The beginner to water-colour painting often makes the mistake of getting the colours much too dark at first, and then there is little that can be done to lighten them.

Hints on Using Water-Colour

It is not always easy to judge how the colour being mixed up in the pan will look when it is put down on paper. A slip of scrap paper should therefore be kept handy to test the colour first. Wet colour often dries to give a lighter colour than when it was first put down. Experience and experiment will show what allowances should be made to get the exact colour required.

If a painter is putting down a colour and realizes that it is not right —it may be too dark or in the wrong place—it is possible to dab the paint out quickly using a tissue. Some colours will leave a stain behind, but most will come off without much trace. If a very good-quality paper

is used, it is possible to scrub out mistakes after they have dried. This can be done with a soft brush or a bristle brush dipped in water, and some tissue. The area must not be worked on again until it has dried out. If this method is used with cheaper papers or cartridge paper, the surface may disintegrate slightly. Any colours that are applied subsequently will probably look mottled, and will have lost their original freshness.

Water-colour painting depends a great deal on the freshness of the paint. Because of this, it is important that the artist should avoid going back over anything that has just been painted. The painting should be left well alone to dry. The water in the jar must be changed as soon as it gets too muddy, otherwise the colours will be affected.

Cleaning Up and Storing

When painting is finished for the day, the mixing pans should be cleaned with a wet rag or tissue; if any paint is left to harden, the pigment will stain the pans. If the paints are not in frequent use, a small piece of sponge, slightly moistened and put in the corner of the paint box, will prevent them drying out.

Sometimes the colours in the paint box become discoloured through being mixed together. They can be cleaned up by wiping over their surfaces with a damp brush or cloth. Paint brushes should always be washed thoroughly in clean, cold water, and the hairs shaped to a fine point. Ideally, brushes should be kept in a special brush case or tube, but any tin or box with a secure lid will do providing it is long enough. Moths will eat sable brushes if they get the opportunity.

Gouache

Gouache is a waterbound paint made with the same medium (gum arabic) as water-colour. A white pigment is added as well as the medium. The result is a much pastier, opaque paint than watercolour—rather similar to oil-paint. Gouache paints are in fact a superior version of the poster paints that many people remember from their schooldays. They can be used thinly, rather like water-colour, using soft brushes to create delicate washes, or they can be used with bristle brushes and treated in the same way as oil-paints.

The advantage of using gouache, particularly to the beginner, is that the paints are cheaper, lighter, and less messy than oil-paints. And they are less daunting to use than water-colours because of their flexibility. There is an acrylic-based medium available to dilute gouache paints; this makes them waterproof. This medium is intended to facilitate *overpainting*—painting on top of an area that needs to be corrected or modified.

Gouache dries relatively quickly, depending on how thickly it is used. This is another advantage to the painter who finds the wetness of oil-paint a problem.

Colours

A range of gouache paints known as 'Designer's Colours' is available. This range of colours is manufactured with the graphic designer in mind. The colours differ from the 'Artist's Quality' oil-paints and water-colours in some respects.

Designer's Gouache Colours

It is almost always better for the artist to work with a small number of palette colours and to mix the colours he wants. However, a very large range of manufactured colours is available. The following is the range of one well-known make of Designer's Gouache:

Burnt Sienna	Purple Lake
Burnt Umber	Saffron Green
Cobalt Blue	Sky Blue
Delft Blue	Spectrum Violet
Lamp Black	Spectrum Yellow
Lemon Yellow	Ultramarine
Light Grey	Viridian Green
Middle Grey	Brilliant Green
Mushroom	Copper Brown
Prussian Blue	Crimson
Raw Sienna	Cyprus Green
Raw Umber	Flame Red
Velvet Black	Geranium
White	Green Lake
Yellow Ochre	Grenadine
Bengal Rose	Indian Yellow
Brilliant Violet	Madder Carmine
Brilliant Yellow	Magenta
Canary	Navy Blue
Coeruleum Blue	Olive Green
Coral	Peacock Blue
Emerald	Phoenician Rose
Fir Green	Process Green
Golden Yellow	Red Ochre
Ice Blue	Rowney Blue
Jet Black	Ruby Red
Light Green	Scarlet
Ocean Blue	Tangerine
Opaque Oxide of	Tyrien Rose
Chromium	Vermilion Red

Edward Burra: Dancing Skeletons *(Gouache). In the hands of a beginner, gouache can often appear chalky and rather flat. But Burra, a great water-colourist, seems to be able to bring the subtlety and depth of colour of water-colour into his gouache work.*

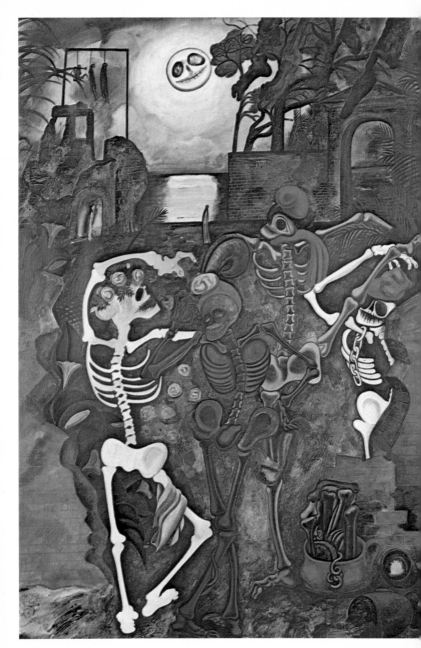

51

Acrylics

Acrylic paint came into use as a medium more recently than oil-paint, water-colour; or gouache. It is made with the same sort of pigments as the other paints, but these pigments are bound together with acrylic polymer resin. This causes the paint to dry extremely quickly, and unlike oil-paint, acrylic paint is resistant to 'yellowing' or darkening.

Acrylic paint is particularly suitable for paintings that need large flat areas of colour, or stripes of colour placed next to each other; if oil-paint were used, the painter would have to wait until the colours on either side were dry. Beautiful effects of transparent colour and staining can be achieved on a very large scale, and quite a thick impasto can be built up.

Acrylic paints are not so suitable when painting an object or a view. In these cases, the artist builds the picture up by a series of marks and colours, often holding three or four brushes in his hand at the same time. This is not possible with acrylic paint: the brushes must be kept submerged in water and this can hamper the artist's thought process.

Some painters dislike the plastic feel of acrylic paint. And some of the colours are not as rich as oils.

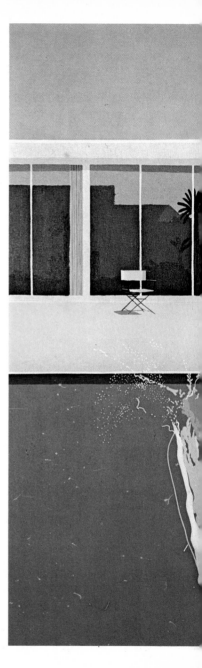

David Hockney: A Bigger Splash *(Acrylic). Even the irregular shapes of the splash, which seem to shatter the symmetry of everything else in this painting, have tidy edges. To achieve crisp, neat edges of one colour against the next in oil paint, it would be necessary to wait for several days for one of the colours to dry. But acrylic paint dries in minutes.*

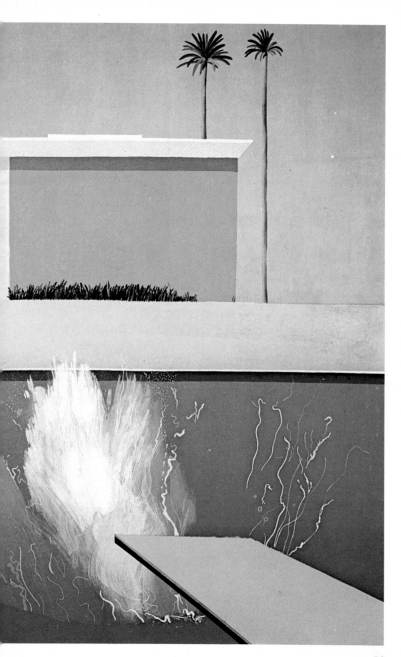

Pastels

Pastels are available in three main varieties: the soft pastel, sold in sticks of about 5 cm in length; the hard pastel, usually sold in pencil form; and the oil-pastel. The soft pastel, appropriately called the 'tender' pastel in France, is the most important of the three. The hard pastel can be used with the soft pastel, but the oil-pastel is quite different and should be kept separately.

The oil-pastel can be used for brightly coloured work on canvas or board, and it can be brushed in with oil or turpentine. Because oil-pastel is not produced in a large range of colours, it is not a suitable medium to employ when the painter needs naturalistic colours, as in landscape painting.

The Soft Pastel

The soft pastel is made from powdered pigment, mixed with chalk and bound together with a medium such as gum or resin. Examples of pastel paintings from the 18th century show how brilliantly pastels maintain their colour, unlike oil-paint or water-colour, both of which tend to fade.

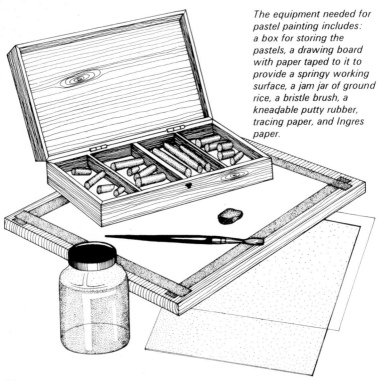

The equipment needed for pastel painting includes: a box for storing the pastels, a drawing board with paper taped to it to provide a springy working surface, a jam jar of ground rice, a bristle brush, a kneadable putty rubber, tracing paper, and Ingres paper.

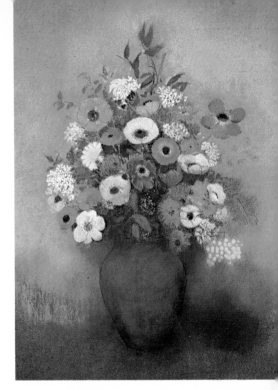

Odilon Redon: Vase des Fleurs *(Pastel). Part of the beauty of pastels is that they retain their purity of colour. And the artist can often achieve the right harmonies of colour simply and directly. With oil paint the colour needed is seldom there in the tube; it has to be mixed, and in the process the spontaneity of the first impression of colour is often lost.*

But because pastels are fragile and crumbly by nature, paintings can easily be smudged, and can even be damaged by vibration.

Because pastels are made from the finest-quality pigment, they are expensive; but they do not deteriorate with age, and each stick will last for a long time. Most of the other equipment required for pastel work can be improvised from ordinary household items. The paper used for pastel work is less expensive than watercolour paper. Pastels are light to carry and provide an economic way of producing paintings. If pastels are used with gouache or water-colour, the cleanness of colour they produce may well enhance or improve the painting.

Colours

When paint is used, colours can be mixed before they are applied to the painting. Pastels can be mixed together on the paper by rubbing them with a piece of cotton wool or a finger, and many artists in the past used this method. However, the result tends to be imprecise, and the colours look muddy. It is better for the artist to have sufficient pastels for the blending of colours to be unnecessary.

Boxes of pastels are available containing from 12 to 150 different strengths of colour. Or pastels can be purchased singly. Each of the pure colours is made in a number of different degrees of strength—from the palest to the darkest tone. A colour such as cadmium red can be

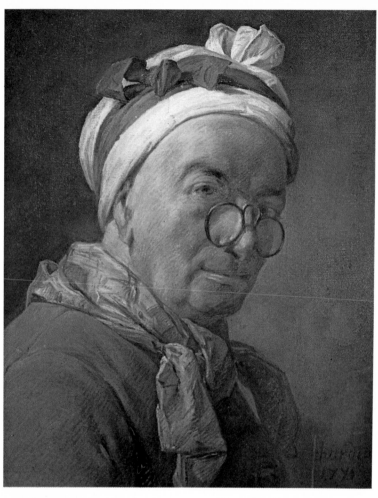

Jean-Baptiste Chardin: Self-Portrait with Spectacles *(Pastel). Chardin painted mostly in oils, but produced some very fine portraits in pastel. He built up this very honest self-portrait by blending carefully, using the pastel more thickly for the light areas in the later stages of the work. This sort of blending can produce dull colouring, but here every part remains amazingly alive.*

purchased at full strength and at four degrees of lightness.

The beginner is well advised to buy single pastels, choosing the same range of colours as has been suggested for a beginner's oil-painting palette. In addition to the pure colours, it is useful to have some lighter tones— a minimum of 36 colours would be a good beginning.

Paper

The best paper to use with pastels is probably Ingres paper. It has a slight texture, and comes in a variety of colours. A good colour to start with is a neutral grey—half-way between black and white. It is possible to buy sketch books containing assorted colours of Ingres paper, but these are usually too small; and so it is better to buy single sheets of paper. Some kind of drawing board is necessary to fix the paper onto. A piece of hardboard or three-ply wood is quite suitable. Some newspaper should be taped down onto the board to give a more pleasant working surface. The pastel paper can be fixed to the board with tape or large 'bulldog' clips.

The artist can hold the board or sketch book in his lap, but for larger work an easel is useful. Because a certain amount of powder crumbles from the pastels while they are being used, it is important that the board is vertical and held firmly. A light-weight sketching easel is suitable for work inside and outside.

Storing the Pastels

The pastels can be kept in any box that has a firm lid—but they should not be able to slide around too much as they break easily. A cigar box or tin is ideal, and a pad of cotton wool on top of the pastels will keep them well packed.

Some colours are more fragile than others and tend to create a lot of dust. This means that no matter how much care is taken in storing the pastels, they can all end up looking the same colour as each other. This means that even with 36 pastels available it can be very difficult to find the right shade of grey in the middle of a painting. There are two

ways of making it easier to find the right colour. Firstly, a box with several compartments can be used, or compartments can be made with pieces of cardboard, so that the main families of colour—the reds, the greens, the browns, and so on—can be kept together. Secondly, if the pastels are to be used indoors, a length of corrugated paper will provide a good surface on which to keep them so that they do not roll around. A well-organized artist could work out an exact order for lining the pastels up, in a similar way to the arrangement of colours on an oil-paint palette. This would make it much easier to find a particular colour.

To keep the pastels clean, some ground rice should be purchased from a grocer. This can be kept in a jar. Every so often some rice should be poured out and the pastels rolled around in it. Ordinary flour can be used in the same way. Or the pastel

The more pastels a painter has, the greater the range of colour available without having to mix by blending. When using oil-paints or water-colours, the various colours can be found easily. But with pastels—using a minimum of 24—searching for a particular colour when all are coated with a similar dust can be extremely frustrating. Some kind of order is necessary, and corrugated paper can be invaluable for making a 'filing system'.

box can be filled with ground rice; this not only keeps the pastels clean but makes the box shock-proof. Some device is needed to filter off the rice from the box before the pastels are used. And, of course, the rice must be changed after a time.

Starting a Pastel Painting

As has been said, it is helpful to have a system of laying out the pastels so that a particular colour can be found easily. A long search in the middle of a painting can break the artist's concentration, and thus the flow of the painting.

Pastels can be kept in their paper wrappers, and the paper torn off as the pastel wears down; but many artists prefer to break off a piece of the pastel so that it can be used on its side as well as with the point. The piece of pastel left behind with the wrapper should be kept as a record of the name and the tint number— this is important if the artist has to buy another stick of the same colour.

If the painting is to be started with an initial drawing, it is better to use pastel rather than a pencil or charcoal. A light grey or blue may be a good colour to start with.

When pastels are used, the work is called 'painting'. Although the artist is not using a brush, shapes and touches of colour are being applied to represent the objects or view that the artist is recording.

Edgar Degas: Sketch for Pagans and Degas' Father *(Pastel). A beginner tends to 'fill in' areas of background with colour, just to get rid of the bare paper. This sketch shows how Degas treated such areas with just as much inquiry—if not the same finish—as the figures.*

Pastel painting has more similarity to oil-painting or gouache than to water-colour, because the pastel makes a solid opaque mark and not a transparent patch. As a result, the order of work can be much the same as that used for oil-painting. The artist begins by looking at a particular piece of colour in the subject to be painted. A pastel nearest in

colour is selected to represent it.

At first, the pastels should be used quite lightly—not marking the colour into the paper too heavily. Pastels are controlled, to a great extent, by the differing amounts of pressure used when they are applied to paper. It is difficult to correct or develop an area of a painting where the pastel has been applied so heavily that the grain of the paper has become clogged up.

Corrections can be made with a small oil-painting bristle brush. The area of pastel to be erased is brushed gently with the bristles, and the dust blown away. Further erasures are then made with a kneadable rubber that can be shaped to a point to use on small areas.

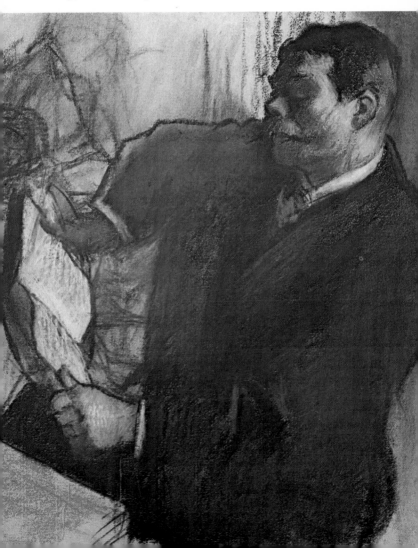

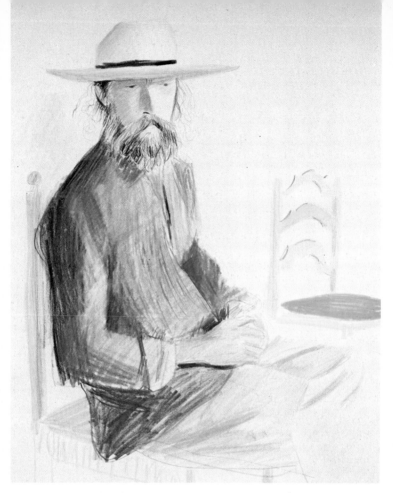

Storing Pastel Paintings

The best way to store a pastel painting is to frame it behind glass—the glass must not actually touch the pastel. The painting can then be hung on a wall that is not disturbed by traffic vibration. However, it would not be feasible to frame every single painting, and so other methods of protecting and storing are necessary.

A liquid called *fixative* can be bought in bottles or aerosol cans. When this is sprayed onto a pastel painting it leaves behind a protective coating that makes the pastel less vulnerable to smudging. However, it is inclined to injure the quality and freshness of the colours, and should only be used occasionally. When applying the fixative, the picture should be lying flat, and only a light spraying should be made. Pastel paintings can be stored in a drawer or in a portfolio, but sheets of tracing paper should be pinned over the top of each to prevent smudging.

David Hockney: Dr. Eugen Lamb, Lucca, 1973 *(Coloured crayons). This drawing is not pencil shaded in with coloured crayons—the type of drawing most people have made as children. The crayons have been used almost as paint—as patches of colour carefully describing what is there. By a system of interlacing lines, Hockney manages very cleverly to blend the colours in the eye of the spectator.*

Charcoal, Conté, and pencil drawings can be 'fixed' by spraying with a colourless fixative. This can be bought either as an aerosol spray or in a bottle with a diffuser. Pastels can also be sprayed; but this should be done lightly because it may rob the work of its freshness and alter the colours slightly.

Protecting Pastel Paintings

Paintings made in pencil, charcoal, conté, and soft chalks are likely to smudge unless they are given some form of protective covering. Several products are sold for this purpose. They are called 'fixatives' and are sold in aerosol cans or with a diffuser. Some artists prefer to leave their paintings in the natural state as they do not like the way that the fixative affects the colour and texture. However, if a pastel painting is to be left without spraying with fixative, it must be protected in some other way. It can be mounted and framed behind glass, but great care should be taken to make sure that it does not touch the glass and smudge. It is also important that the framed painting is handled carefully to avoid the pastel being shaken about—creating dust that will be trapped inside the frame.

If the painting is to be sprayed, it should be placed flat, preferably on a drawing board. The spray should be applied lightly and evenly, starting from the top left hand corner of the painting and working downwards from left to right. Fixative gives off a vapour that can be harmful if it is used in a small room without ventilation. The painting should, ideally, be sprayed out of doors or in a well ventilated room.

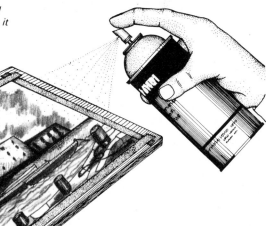

Egon Schiele: Arthur Roessler Standing with Arms Akimbo *(Black chalk). This drawing consists mainly of outlines. Some are thin and sensitive, for example those describing the nose and eyes, and others are rather coarse, for example those of the clothes. Generally, an artist starting a drawing does not think about the method he will use—outline, shading, dots and dashes, or smudges; the drawing takes over, and he may use any combination of these.*

The Approach to Drawing

The copy of the drawing by Egon Schiele was done by a child of twelve. The result is a strong drawing, but it contains a number of mistakes of the sort commonly made by beginners. In the first place, the head in the copy is wrongly proportioned. The portion above the eyes is much too small—in the original the top half of the head is rather larger than the bottom, and the tops of the eyes and the ears are half way up the head.

If a pencil or a piece of paper is placed across the top of the ears in the drawing by Egon Schiele, it is clear that the tops of the eyes also lie partly on that line. In the child's drawing, the eyes are much farther up the head. So it is important for the beginner to see whether different features can be linked up along the same line. Taking Egon Schiele's drawing again, the bottoms of the ears are on the same level as the bottom of the nose, and the top of the right shoulder is level with part of the knot in the tie—but the left shoulder is a little lower. In the child's drawing, the shoulders are too low down. If a pencil or a piece of

Copy by a 12-year-old child of Egon Schiele's portrait of Arthur Roessler. Most people learning to draw have difficulty in observing correctly and in putting down on paper what they have seen. This drawing shows several of the most common problems, such as getting proportionate sizes wrong and getting angles wrong. The artist has to train his eye to observe, just as the musician must train his ear.

paper is turned vertically—lying straight down the drawing—other details can be linked together in the same way. The left ear in Schiele's drawing is on the same vertical line as the thumb sticking into the waistcoat pocket. In the child's drawing, this is not so, and the whole stance of the figure in this drawing is quite different from the original.

Using these linking lines may seem like a simple exercise suitable only for copying a drawing. But exactly the same method can be used when drawing a real object.

First of all the artist should look to see if there are any obvious things lying on the same line—like the tops

of the ears, and the tops of the eyes in Schiele's drawing. This can be tested by holding a pencil, either vertically or horizontally, at arm's length. The pencil must be held absolutely still. One eye will have to be closed in order to be able to focus properly. It is important that the same eye is used throughout the drawing, and if necessary a note can be made in the corner of the drawing as a reminder.

This process may seem laborious, but it does help to train the eye to notice the relationship of one object, or part of an object, to another. By using it, the artist will learn to draw in proportion. After a time, through

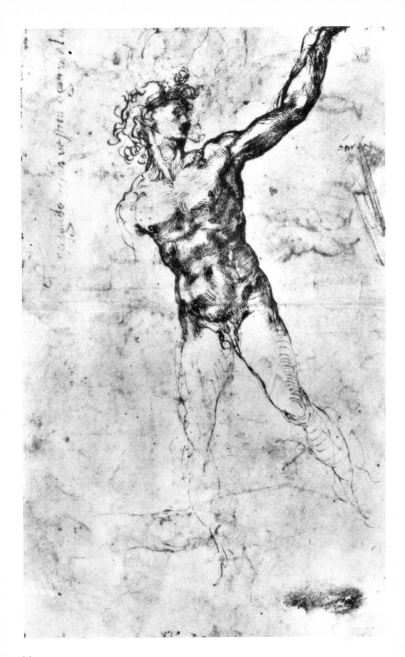

64

Michelangelo: Study of a Nude Youth (Pen and ink). Michelangelo was fascinated by the working of the human body as a mechanism. Many of his drawings, including this one, are studies in which he was trying to understand how the various parts of the body linked to each other in a particular pose. Sometimes, his lines of shading follow the curve of the body —on the left leg, for example—and at other times he uses areas of straight lines. But always his drawing describes carefully how the body's parts interconnect and change their roles as the body moves.

practice, the eye will become much more accurate at judging distances and shapes.

Drawing Angles

Apart from learning to line objects up, it is important for the artist to be able to gauge angles correctly. If the angle at which the arms slant in Schiele's drawing is compared to the angle of the arms in the child's drawing, it is clear that in the latter the upper parts of the arms are sloping down too sharply, but the lower parts are at the correct angle. The beginner often has difficulty in getting things to slope in the right direction and at the right angle. The problem is worse if the subject is sloping towards the artist; this can happen with buildings or a table top.

The theory of perspective is complicated, and can prove bewildering to the beginner. So it is better for the beginner to take each case as it presents itself, to study it hard, and to decide on the right angles. The pencil can be used to measure angles, in the same way as it was used to link things up on a line. It should be held at arm's length and slanted so that it

is at the same angle as that of the object being studied. The pencil is then lowered—keeping it at the same angle—so that it lies flat on the paper. This will give the artist a good idea of the correct slant of the object.

Using the Gaps Between Objects

Another extremely useful lesson can be learnt from the child's drawing if the gap between the arm and the side of the coat is compared with the gap in the original drawing. This small empty space makes a definite shape, and if the artist gets it right, drawing the arms will be much easier. Empty spaces or gaps—gaps between fingers, gaps of sky amongst foliage, spaces between the leaves of a tree, bits of wall behind flowers—are often a great aid to the artist.

It is worth studying the way in which Schiele has drawn the narrow strip of space between the side of the coat and the trousers on the subject's left side. He has drawn it very carefully as a definite shape, rather like a lake or a river on a map.

Shading

Several methods of shading have been used in the drawing of the young man. by Michelangelo. If the shading on the right leg is studied, it will be seen that the artist has made the lines go round the leg as if there were bits of string tied round it. The lines are curved in this way because the artist was trying to show the roundness of the leg at that particular point. Each curve stops and starts and bends differently from each of the others. This method of shading is not just a matter of drawing rings round the leg at random: each curve is carefully observed so that it shows exactly how the leg is rounded.

It will be noted, however, that the curved lines on the thigh go only a quarter of the way round. The shading is unfinished, but this is because shading is linked to shadow: it provides a way of making an area on a drawing darker where it is darker on the object.

In Michelangelo's drawing, the light is coming from above and slightly to the left. The thigh is bent a little at the knee, and because it faces forward it receives a lot of light. The part that curves away on the right side is in shadow, and so this is where Michelangelo has placed his shading.

On the upper part of the body, some of the lines are straight and are all slanting in one direction, others are curved. Each direction of line that Michelangelo has drawn serves the purpose of explaining the structure of the subject's body—for example, where the shape of the body changes between the navel and the side of the stomach, and what shape the muscles make in an uplifted arm.

It is interesting to compare the drawing by Michelangelo with Manet's *The Queue in Front of the Butcher's Shop*. Manet uses shading in a different way. Some of the lines are going in a direction that shows the curve of the object they are describing, whilst others serve a different purpose. For example, the shading on the umbrellas is not designed to show how an umbrella is constructed but simply to indicate that some parts are darker than others. Manet is more interested in the beautiful patterns that shadows make and in the way that figures in dark clothes, standing together, become a series of dark patches. If each umbrella is studied, it will be seen that

although a few of them have an outline drawn round them, it is the patches of shadows and the white paper left that really describe their shape.

Both artists use shading in different ways to show what interests them most in the subject they are drawing. However, they are both using shading to copy the shadows—the areas where there is no light on the object. The beginner often finds it difficult to see a subject in terms of light and dark, and to see the patterns that shadows make.

There are two important things to remember when shading. Firstly, shading is not just a question of making scratchy marks to improve the finish of a drawing. It should represent a patch of dark that can be seen on the object. Secondly, if the shadow is consistently dark, the shading must show this, and the artist should avoid leaving uneven streaks of white paper in between the shading or overworking some areas and making them too dark.

Selecting Details

An important part of drawing is the search and selection that goes into finding subjects to put down on paper. An artist studies his surroundings for their visual qualities. Other people may see the same surroundings in a different way.

When making a drawing, an artist selects certain shapes, tones, and lines from what he can see in front of him. This is probably one of the most difficult parts of drawing. The beginner does not always realise how difficult the selective process can be, and gets worried when his drawing goes wrong. Reassurance can be had by studying some of the old masters.

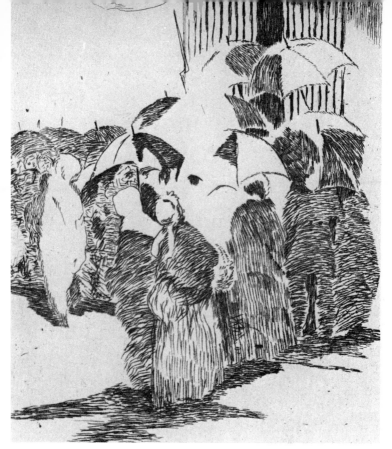

In the drawing by Ingres it is clear that the arm on the left has been drawn no less than five times. The artist kept distilling what he saw until it was just right; in spite of these corrections, the result is a very beautiful drawing. The beginner should never worry if a drawing is not right first time. Corrections will not ruin it, and anything that brings it nearer to the truth will be an improvement.

Many artists begin by doing a rapid sketch of the whole thing they are drawing, and then improve and refine it in detail afterwards.

Edouard Manet: Queue in Front of the Butcher's Shop *(Pen and ink). In this drawing, Manet uses shading in a way quite different from that of Michelangelo in his* Study of a Nude Youth. *In both drawings, the shading describes the darker areas. But Michelangelo is trying to show how a body works, so that it would almost be possible to reconstruct a human figure from his drawing and sculpt it. Manet, however, is more interested in the patterns the shadows make; and sometimes, the feathery little lines he uses convey the woolliness of a shawl or the tautness of an open umbrella.*

Jean Auguste Dominique Ingres: Lute Player *(Pencil). Beginners often think that it is necessary to be able to draw something perfectly straight away. This work by Ingres shows that drawing is not a matter of instant results but a process of refinement.*

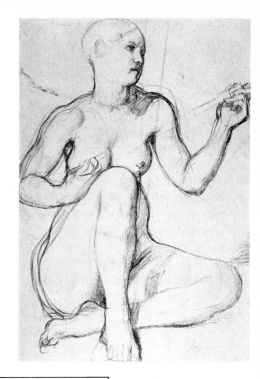

Shading

There are many different ways of shading; a few examples are shown here. Left to right, from top: straight lines, lines made darker by crossing them, curved lines, dots or scratches, gentle filling in with a pencil, solid charcoal, solid conté, brush and wash, smudging with a finger.

Vincent van Gogh: Montmajour *(Reed pen and ink). There is a popular idea that details are unnecessary in drawing and should be left out—that the artist should generalize. This drawing is packed with detail of the most beautiful kind, and seems to possess the perfect balance between detail and simplification.*

How Much Detail to Include

The foreground of the landscape by van Gogh shows the ideal blend of simplification and detail; he has not drawn every blade of grass, nor has he ignored the untidy piece of land, or covered it in random scratches of the pen to give a lazy impression of grass. Van Gogh has drawn the details as carefully as he could in the time available. He has studied the scene and chosen the most prominent pieces of grass to draw.

Objects such as hair, leaves, and grass, and certain complicated patterns can present a problem to the artist. There are two extremes to be avoided. Firstly, the artist should not look at a tree covered with a complicated leaf system and decide to put down a series of scribbled lines to give an 'impression' of what he sees. And secondly, he should not be a slave to detail, conscientiously drawing in hundreds of leaves, and forgetting the tree itself.

The most useful lesson the artist can learn from van Gogh regarding detail is not to panic and not to go to either of the two extremes—sloppy or over-meticulous. Each area of a drawing should be treated carefully and as a part of the whole. Van Gogh never generalizes in a lazy way, but selects certain shapes and shadows to describe simply what is there.

Colour

Using colour and becoming familiar with its strengths and subtleties can be an enriching experience. Quite ordinary scenes and objects become suddenly of interest when they are looked at in terms of colour to be reproduced in paint. Pavements, hitherto unstudied, will now be seen to have beautiful splashes of colour. Familiar brick walls, even those begrimed by fumes, become areas of gentle pinks and cool blues. And patterns on the seat of a bus will raise the questions: why are they so dull and how could they be improved?

A person newly aware of colour will find, too, on visiting art galleries that paintings previously without much appeal now have a touching beauty. This beauty probably cannot be explained in words, for colour is an emotional experience.

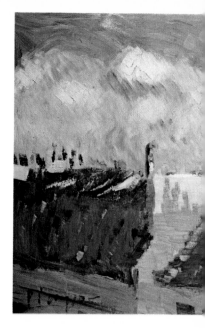

Outlines

Most people will know those children's painting books in which outlines are already drawn in ink, and the child simply fills in the shapes with water-colours. But in the real world there are no outlines showing where one thing begins and another ends. What the observer sees is patches of colour, and that is what the artist must depict.

If, for example, an artist wants to paint a view consisting of a pavement framed by the foliage of trees on either side and with a field of grass beyond, he must take some grey for the pavement, some green for the trees, and some green for the field. Now if this view was shown in a children's painting book with its various components drawn in, it would not matter what particular greens or greys were used, because the outline would always explain what was happening. But in real painting, the colour alone has this function, and the right grey and the right greens must be chosen. If the painter puts on a colour that is too muddy or too lurid, then the painting will not 'work'.

Learning to use colour means matching the colours in the view that is being observed, and putting them down in the same shape and appearance as they have in real life. This is not easy in practice, but the painter must try to hold on to the essential simplicity of the idea.

Play of Colours

Anyone who is conscious of colour in their clothes knows that certain colours enhance their complexion

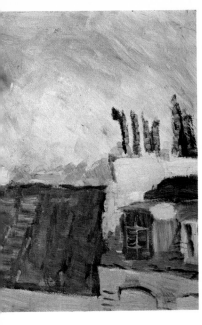

and show it to its full advantage, and that others will make their skin look pale or sickly. The reason is that colours are changed and affected by each other. One rather dull colour in a painting can suddenly come to life when the painter adds another that sets up a vibration with the first. A patch of colour that seems warm on its own will seem insignificant when a still warmer colour is applied next to it. Every dab of colour the artist puts down affects what is there already.

This is particularly true of such paintings as abstracts that depend entirely on the play of colours against each other.

Practical Approach to Colour

Perhaps the best way to discuss the use of colour is to take three simple everyday objects, place them on a table, and try to paint them. A good choice would be a plain red book, a brown envelope, and a piece of white paper. They are not chosen for their beauty of colour or as interesting objects but merely as things to experiment with.

Probably one of the opaque media —oils, gouache, or even acrylic— would be best for the experiment. All the colours should be set out: although no green, blue, yellow or crimson may be apparent in the objects to be painted, these colours may be needed to make some of the mixtures. Ideally, the fewer colours used to make one mixture the better. But beginners inevitably make mistakes and need to use several to get the colour desired.

It is a useful experience to mix each of the colours on the palette with each other colour, and to mix some

white into the darker colours to see what is produced. Unusual combinations, such as a little red mixed with green, can produce very lovely colours.

Black and white make only one sort of grey; there are many others, such as the greys produced by mixing cadmium red and viridian with white, and mixing ultramarine and light red with white. Some colours—for example, alizarin crimson—penetrate a mixture strongly, and must be used sparingly.

First step. The outline of the objects should be drawn accurately but briefly, using a pencil or paint and a brush. The objects should be shown close up.

Second step. The main colour of the red book should be mixed up. At first a bright red straight from the tube may seem correct. It may even be correct, but, more likely, something else may have to be mixed with it. When the mixed colour seems right, some of it should be painted on the corner of a piece of scrap paper and laid on the book. It may now look too light or too dark, too bright or too dull. When it is right, a little of it should be painted on the drawing of the book. Then the brown envelope should be started in the same way.

A good way of matching up colours is to use a piece of white card, such as a postcard, which has a hole in it about the size of a pea. The card is held some distance from the eye so that the light falls on it; by looking through the hole at the object being painted, a section can be isolated and its colour studied.

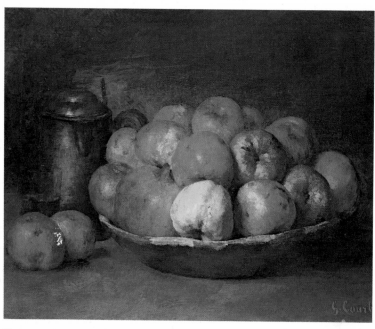

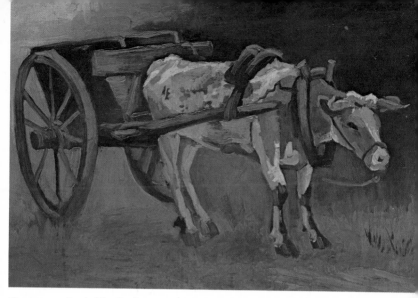

Vincent van Gogh: The Ox Cart; Red and White *(Oil). The sombre colouring of this painting is not what most people associate with van Gogh. Towards the end of his short career as a painter, he said that he cared nothing for the colour of objects in reality; he cared only for the brilliant colours he could mix on his palette. Nevertheless, his early work, as with that of many great colourists, was dark, and his colours were close to nature in their careful observation of tone. A personal sense of colour grows gradually only after much study of the colours in nature.*

Gustave Courbet: Still Life; Apples and Pomegranate *(Oil). It is an interesting experience when walking round an art gallery to stop before a painting that seems particularly brilliant and glowing and see just how much of the painting is actually brightly-coloured. Often, there are remarkably few patches of glowing colour or highlight: it is the careful painting of the less intense colours that gives the picture its luminosity.*

A little of the mixed colour can then be painted on the card beside the hole (leaving no white between it and the hole) and matched up.

Third step. When the envelope colour is right, a patch of it should be put on the drawing, and the mixing of white for the paper started. A beginner may well think: 'White paint is white paint and does not need any mixing'. But in fact there are many varieties of white, and they cannot always be matched straight from the tube. Some whites are slightly orange, others veer towards blue or purple. They are not, of course, decidedly orange or decidedly blue, but in distinguishing between whites it is helpful to think in those terms. Only the minutest particle of a colour is needed to make the white lean in that direction.

White from the tube is used in its pure state very rarely. It is the lightest colour, and must be held in reserve to preserve its impact.

If white is used indiscriminately for light, or all the highlights, it will

make the painting look speckled and chalky. Most highlights are not white, anyway. They take on the colour of their object or the colour of the light that is causing them. Artificial light, for instance, is frequently rather a warm orange-like colour and creates a similar highlight.

If certain light things, such as reflections on water, some skies, or an electric lamp, are observed through the hole in the card, it will be apparent that no paints in the tubes are bright enough to provide a colour match. This shows that a completely accurate matching of colour is impossible— and some darks are unattainable as well as some lights. It also shows how colours affect one another, for these light things gain their full impact from the colours around them. It takes a little time for a beginner in painting to become accustomed to the subtle ways in which colours affect each other, and it is important not to be discouraged and to try to match each colour as closely as possible.

Fourth step. When the three colours are right, they should be placed in the painting where they come on the objects. The work of painting should now be done without the use of the card; the painter must try to train his eye to judge the colours right. The reason why the whole book was not completed in detail as soon as the red was mixed was because of the effect colours have on each other, as has already been seen. If the book had been carefully painted immediately, its effect might have been changed when the envelope and paper were painted. It is wise to make a habit of working on two or more different areas at the same time —or at least considering a few areas

at the same time. A good way of continuing the painting would be concentrate on patches of colour that lie next to each other—a corner of the book against the shadow it casts on the envelope, for example.

Fifth step. The red book will cast some shadow on whatever lies next to it, and perhaps its spine will be in shadow. This will of course depend on the direction from which the light is coming and how the objects have been placed.

Shadows generally seem difficult to paint at first. They are definite colours in their own right, but usually less strong than colours in the light. The painter must not assume that they are just a dirtier version of the main colour, and add black or brown in order to capture them. They must be treated as just as important as anything else.

At first, the tendency will be to make them too dark. But if they are studied through the hole in the card, it will become apparent that they are less dark than they seemed at first.

The print on this page is very dark against the white of the paper. But this degree of contrast is rarely found in nature. If a thumb-nail is studied,

Ernst Ludwig Kirchner: The Artist and Model *(Oil). Much of what has been said about colour is concerned with training the eye to notice how colours relate to each other. But many paintings are not so much to do with 'natural colour' as with colour used decoratively or to express emotions. In the same way that music can soothe us or make us anxious, colours can suggest feelings and emotions. In this painting, the atmosphere of the room is conveyed as much by the colours as by the expression of the model.*

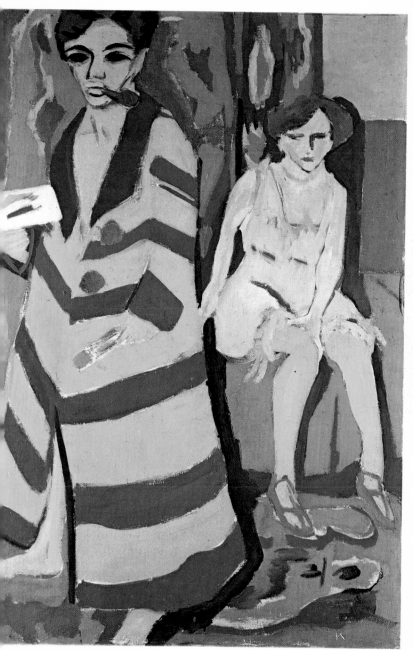

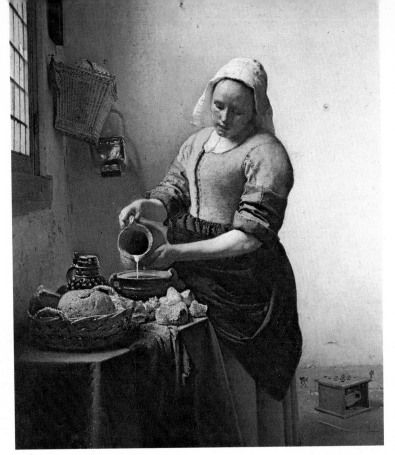

it will be seen to be similar in colour to the skin beside it. But is it lighter or darker, and if so to what degree? In many things that are being painted, the colours will vary only slightly in degrees of light and dark. Their variations should be reproduced as faithfully as possible; they do not have to be exaggerated to achieve an appearance of reality. If colours are close together in reality, they will look right if they are close together in paint.

Sixth step. As the painting progresses, each new colour should be put down as a specific shape, matching the one in the original object. It will be observed that even on a 'plain' book there will be several small changes of colour. These must be fitted together like a jigsaw puzzle.

At this stage it does not matter if the edges of the colours meet rather abruptly. In time, as the beginner's eye becomes more accurate, it will be seen how colours change gradually and melt into each other. This is not a matter of blending with a brush, but of matching the colours so delicately that where there is no harsh edge in reality, there is none in the painting.

Vermeer van Delft: The Cook *(Oil). It is often said that the painter should never copy nature. Anyone who has tried to do so will know it to be an impossibility, but the attempt has produced some of the world's greatest paintings. The serenity of this simple scene shows Vermeer's love of the beauty of ordinary things.*

Claude Monet: Impression: Sunrise *(Oil). This painting was obviously done in a hurry, but what interested Monet was colour. As Ruskin wrote about rapid colour sketches: 'Never mind though your houses are all tumbling down—though your clouds are mere blots, and your trees mere knobs, and your sun and moon like crooked sixpences—so only that trees, clouds, houses, sun and moon are of the right colours!'*

Points to Remember

As a painter puts on colour, he must be prepared to forget what object he is painting. The red book, brown envelope, and white paper may be quite unrecognizable in the picture. But the painter must not worry about this. 'Likeness' will come as the painting progresses. Putting in all the details of the lettering on the book, or accentuating the modelling to make it look three-dimensional, will not help at this stage. The important thing is to concentrate on getting the colouring right, and not to be put off by anyone suggesting it looks like an abstract, or a sunset!

However absurd a colour may seem, it should be put in if it is there. At the end, it will look right.

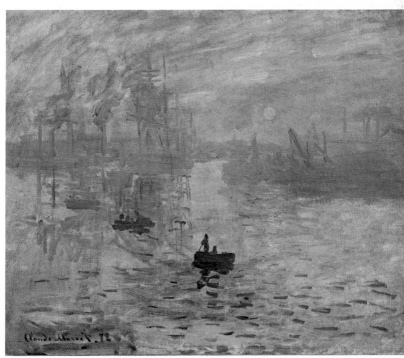

Keeping a Sketch Book

After some experience of drawing and painting, the beginner will find new interest in colours and shapes: the eye becomes tuned to the beauty in even the most unlikely things and places. It may be the shapes of the spaces between cigarette stubs in an ash tray that will suddenly seem interesting—artists have often found beauty in things that others have thought ugly. A group of figures waiting for a bus may attract attention because of the silhouette they make or the reflection of the evening sun on their faces. Keeping a sketch book and making a note of things like this is an invaluable way of developing the eye and of building up source material for later use.

Any sort of paper will do to keep notes on—a newspaper at breakfast to note the shape of the remains of a boiled egg, or the back of an office envelope to jot down the shape of a cloud. Of course, it is better to make such notes in a way that can be used for permanent reference. Sketch books are available in most stationers' shops that will fit comfortably into a pocket or handbag.

It does not matter how bad a sketch is or how short a time is available: the fact of switching off from the normal run of life and looking at something in a concentrated way will help to train the eye in the judgements needed to be made in painting. As with listening to music or playing music, practice is essential. The eye must be kept exercised. This does not mean that practice is an effort. On the contrary, many painters find after a while that they want to draw everything they see: fitting in the rest of the things that have to be done becomes a difficulty!

The artist who is interested in sketching people gets countless

opportunities for practice. In pubs and cafés, on trains and buses, and just on the other side of a window, there is an endless selection of subjects waiting to be put down on paper. The painter Renoir, working from a window overlooking a busy street in Paris, is said to have persuaded his brother to go down into the street and stop passers-by to ask them the way or some other question, so that Renoir could put their figures into his paintings. This sort of thing may not be easy to arrange! But trying to draw walking figures can be great fun, and the result matters less than the fact that the person making the sketch begins to understand the shapes people have when they are walking, and the way the parts of the body interrelate.

If a more captive audience is being sketched, in a train or café, it is better to avoid letting them know they are being studied—they will become self-conscious and will probably also ask to see the sketch. It is better to choose two or three people, and when one of them suspects what is happening, switch to another; then switch back again later on. In this way, quite a complicated sketch can be completed. But it may be more useful, when time is limited to a few minutes, to concentrate on the general attitude of a figure or group of figures rather than to worry about features and details.

J.M.W. Turner: Helmsley Castle *(Pencil). Keeping a sketchbook is an excellent way of developing powers of observation. Turner was a compulsive sketcher.*

Eugène Delacroix: A page from the Moroccan Sketchbook *(Watercolour). Delacroix used his sketchbook not only as a source of material for use in his large oil paintings, but also for the sheer joy of recording little fragments and incidents of his travels.*

Composition

Composition means quite simply the way a painting is put together; how the subject is arranged on the paper or canvas. To the beginner this may not seem very important. It is obvious that if a particular view is being painted, the painter has to make sure that it will all fit on the canvas. Equally, a painter working on a portrait does not suddenly realize that there is no room left for the top of the head. There is a story of a stone-carver who carved on a gravestone 'Oh Lord, she is thin', because he had left no room for the last 'e'.

Every painting, though it may be done simply for the reason that the artist wants to paint a particular subject, makes a design. Any mark or shape put down on a piece of paper will set up margins and proportions with the edges of that paper, and with other marks on it; and these proportions can be pleasing or not. If they are pleasing, the design is good.

Many of the painters of the past used geometry to help them plan out where things would go in their paintings. Certain proportions were found to be more pleasing than others, and it was seen that a painting divided up skilfully possessed an underlying harmony.

Other painters let their works grow gradually, trying out a certain

James Dickson Innes: Waterfall (Water-colour). Composition, when landscapes are being painted, is very much a matter of finding the right view. The most interesting thing about this picture is the pattern the three waterfalls and the river make down the painting. From a viewpoint to the left or the right, the composition would have been quite different.

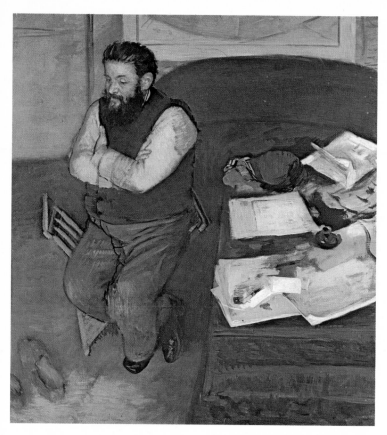

arrangement to see how it looked, and then shifting it around—rather like organizing the furniture in a room. It can be fascinating to make little sketches of pictures seen in galleries or in reproductions and to try to enter the mind of the artist, and see how he decided on the arrangement of his ingredients. This is probably a better way of learning about composition than applying any rules.

The commonly quoted rule that a painter should never place his main object in the centre of the picture was broken by many great painters of the

Edgar Degas: Portrait of Diego Martelli *(Oil). Degas was very conscious of composition, and made many drawings of this pose before the final painting in order to arrive at the best placing of the various objects. The unusual viewpoint gives the spectator the impression of taking the sitter by surprise. Degas did in fact, talk of looking at things as if through a keyhole.*

past, whose works depended on just that equal symmetry to achieve harmony. John Ruskin in his very helpful book *The Elements of Drawing* gives a list of the 'laws' of composition; and providing that these are not taken as absolute, they can assist in developing a deeper appreciation of composition in paintings— and can lead the painter to seeing new possibilities in his own work.

The need for good composition becomes more evident when a painter is making a picture from imagination: then he has to decide where to put things and what colours to use. If, for instance, he is painting an incident from the story of Jonah and the Whale, he must at some time make up his mind how large the whale is to be, and in which direction it should move. He must also visualize the sea against it, and so on.

This does not mean that design is any less important when an artist is painting a view or object that has a real existence. But he must approach the question of design in a different way. In portraiture and still life, he can, of course, arrange his subject as he wishes and can, in this way, compose his picture to some extent even before he paints it. In landscape painting, however, composition depends largely on selection; the artist must choose his view carefully since

Edvard Munch: Dance on the Shore *(Oil). In this painting, Munch was not describing something he was looking at. It may have come from memory, or may have been imaginary. This kind of painting requires decisions from the artist on colour and shape as well as composition. Munch seems to have arranged it all so that the parts of the painting echo the rhythm of the dancing couple.*

Peter Paul Rubens: The Château de Steen *(Oil). Sometimes the artist cannot predict the composition of a painting until he is in the middle of it and feels the need to expand certain areas or restrict others. This painting began as a panel, but 16 extra pieces of wood were added.*

Practical Hints on Composition

When a painting has been finished, it is a good idea to stand it up, or hang it somewhere where it can be studied from time to time. Having lived with the painting for a time, the artist may decide that it can be improved—a landscape may contain too much foreground, or a portrait may look better if the arms or legs were cropped slightly. These improvements can be tested by pinning pieces of grey or white paper over the areas in question. If the artist decides the painting does look better, it can then be mounted and framed accordingly. If, however, the artist decides that the painting needs to be added to, a piece of paper can be stuck on and the painting continued. This is more of a problem when board has been used, but if canvas is used, extra pieces can be sewn on.

The artist should avoid using too many bright colours in one composition. Even when an artist uses colours that are similar, they are often set off by a small amount of quite a different colour; a lot of green may be set off by a small amount of red.

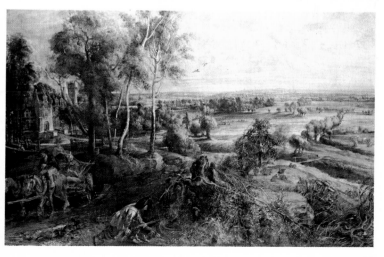

he cannot change it. Much about design can be learnt from the photographer, who has to think closely about how much or how little is going to appear in his frame.

What Sort of Subjects do You Want to Paint?

Most paintings can be put into general categories: landscapes, still life, portraits, paintings from imagination, abstract paintings, and so on. These categories are slightly artificial, but they are convenient for discussing certain practical considerations related to each subject. An artist can, of course, paint anything he wants, and mix all the categories up. The portrait of Lytton Strachey is not merely a portrait, but contains features that could be described as landscape or still life. The choice of pose and the setting are very imaginative in the sense of emphasizing Strachey's height and thinness. And the painting also has abstract qualities in the choice of certain shapes and the fact that the sense of design has been given great importance.

When people know that a person paints, they often ask 'What is your subject?' This is sometimes a difficult question for a painter to answer. It may be a view or an object that catches his attention, or the fall of light, or a particular colour—and it does not matter particularly what the colour is on, whether an umbrella or a tree. Some painters do have a definite thing that they like painting —horses, or flowers, or red haired girls—but most probably try to paint different kinds of subjects from time to time, because such a lot can be learnt from looking at various sets of colours and shapes. In the same way, painting on different sizes of paper

Henry Lamb: Lytton Strachey (Oil). Artists have individual preferences for the type of paintings they want to make: some paint only portraits, others only seascapes. But the division of paintings into separate compartments can sometimes lead to rather artificial pictures. Still-lifes, for example, tend to be groups of objects that would not come together in the normal course of life. Although this painting is a portrait, the greater part of it is a landscape, and there are some finely-observed pieces of still-life. All these seem to relate to the character of the sitter: the long, thin window bars, the spindly umbrella, and the spiky branches.

or canvas—that is, painting to different scales—can lead an artist to making new discoveries in his painting.

Practical reasons will play quite an important part in the beginner's choice of subject. A person who likes painting heads but finds his friends reluctant to sit as models, may end up doing many self-portraits. Somebody who lives in a town but wants to paint landscapes may have to paint from drawings or even from photographs taken on holiday.

But there are always many quite ordinary subjects around that are very paintable but may not immediately attract the beginner's attention. A good example is the view into a room in the painting by Sickert on page 87, in many ways it is rather an uninteresting view, but it has provided the artist with enough material to produce some lovely combinations of colour and shape.

Below: Antonello da Messina: Saint Jerome in his Study. *It is interesting to compare the claustrophobic atmosphere of Sickert's painting with this airy, spacious interior. Although Saint Jerome seems unaware of our presence, the carefully thought-out composition and delight in the use of perspective makes us believe that we can walk up the steps, past the peacock, and into the saint's cell.*

Right: Walter Sickert: L'Armoire à Glace. *Sickert described the artist as one 'who can take a piece of flint and wring out of it drops of attar of roses. This painting shows what beauty of colour and shape can be found in a view into a rather shabby room. The figure is part of the view: Sickert believed that a figure should be part of his surroundings—he disliked formal poses.*

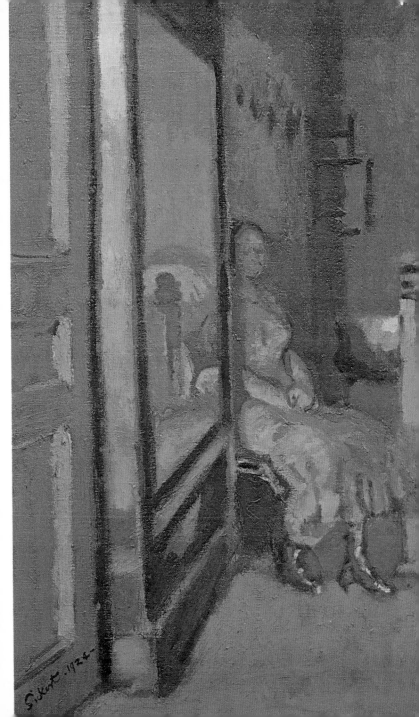

Landscapes

Because of the complexity of painting grass, trees, and bushes, it is helpful to see things in larger shapes at first. If there is time, some careful studies can be made of leaves, branches, and grass. But when a painting has to be finished in one day, it is necessary to see groups of trees and grass as masses. Often, the sunlight will break the view up into pieces of dark and light that the painter can depict.

Trees and Foliage

Massing-in the shapes is particularly useful when coping with trees. In summertime, when the branches are amply covered with foliage, the painter should try to make out how they form themselves into clumps, and take particular notice of any pieces of sky showing through them. These holes will seem like the missing bits in a jigsaw puzzle, and it is important to get their shapes exact, for they will help to describe the tree.

Unless a tree is very close, it is not possible to see many of its leaves individually. But the leaves at the edges of the foliage can be distinguished when they stick out as silhouettes against the sky, and it may be possible to see some where a part of the tree is turning into shadow: these leaves should be painted as carefully as possible. But it is rare to see a whole tree spotted with individual leaves, and the painter must resist the temptation of putting on colour with a kind of stabbing motion to give the 'impression' of every leaf.

In winter time and in spring when a lot of the branches are showing,

they make lovely although rather complex shapes. 'Panic painting' all the small branches and twigs by dashing them in roughly should be avoided. A main branch should be picked out and, if possible, followed patiently to its extremity, all its major offshoots being put in: the painting will then have much greater reality and authority than if no branches were painted in detail.

The chocolate-brown colour that children tend to mix up for the colour of tree trunks and branches is rarely found in nature. The wood of trees varies much from green greys to rather pink browns. These colours need mixing: a colour straight from the tube—burnt umber, for example —is usually too strong and harsh to be realistic.

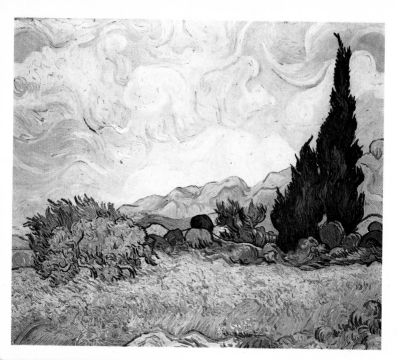

Vincent van Gogh: A Cornfield with Cypress Trees *(Oil). In painting the trees and bushes, van Gogh does not paint every leaf, nor does he over-simplify. He examines how the tree grows—its structure and the way it is arranged, like the clouds, into clumps of rounded shapes.*

John Constable: View of Dedham *(Oil). Constable would go out into the countryside and sketch simple views that most people would pass without noticing. Such paintings as his* Leaping Horse *are put together carefully from the experience of light and landscape gained from little paintings like this one.*

Overleaf: John Constable: Stoke-by-Neyland *(Oil). Although he often sketched Stoke-by-Neyland, this painting has all the freshness of a scene observed for the first time.*

Foregrounds

The examples of landscape paintings in this book show how seriously artists treat the piece of ground in front of them—the foreground—however insignificant it may seem. Of course, the centre of interest in a painting is seldom a daisy in the grass by the painter's toe, but something more dramatic in the distance, and the painter obviously has to spend more time on that. But the untidy clumps of stubble and grass, interspersed with patches of earth, or fences and hedges, that so often are the nearest thing to the artist can make fascinating patterns of colour if they are treated as something worth looking at. It helps the painter in his work if he links them up to a part of the landscape in the distance, saying, for example, 'This clump of weeds lies immediately below that cottage in the distance.' The painting by Constable on this page, *The Leaping Horse*, consists largely of untidy foreground. Constable made a number of sketches of parts of this foreground—the wooden stump and the moorhens, and the wet and shining bits of wood. This painting shows how beautiful quite ordinary things can be if they are looked at lovingly.

Mixing Greens and Greys

Many different green coloured paints are sold, but it is probably best for the beginner to limit himself to one—viridian, for example, or oxide of chromium. Considerable experience is required before the eye learns to distinguish one green from another and, in a landscape painting, the distinction between greens may be the only way to tell what parts of the picture are about. A colour such as viridian is so unlike anything found in nature that the artist is obliged to think a bit harder about what he is painting: is that field a yellow green or a grey green and what colours should be mixed in to give a feeling of reality? A colour named *sap green* looks rather like many colours in trees and fields; the beginner is tempted to use such a colour everywhere in a landscape painting. If he does so, the result will be dull and untruthful.

When a landscape displays a variety of green fields, trees, and hedges, the painter can distinguish between them by asking himself questions. For example: 'Which is the darkest, and which is the lightest?' 'Is one bluer than the rest?' 'Is it yellower or browner or greyer?'

Some greens are stronger than

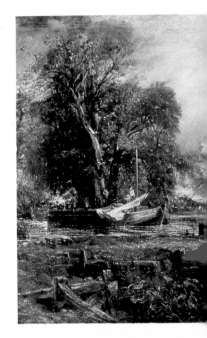

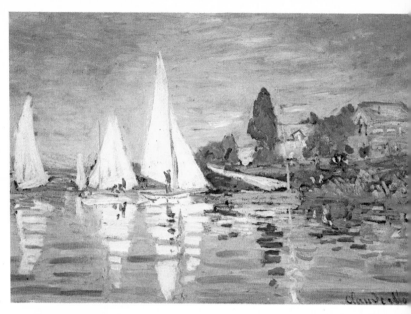

Claude Monet: Les Regattes Argenteuil *(Oil).*
There is no mysterious technique involved in
painting reflections successfully. They are simply
patches of different colours, like the rest of the
painting.

John Constable: The Leaping Horse *(Oil). The*
landscape painter may be disappointed that
dramatic subjects of this kind are not found easily.
But Constable was not seated by the river bank
capturing this scene. The parts of the painting
were brought together from his memories of such
scenes as the moment when bargee horses leapt
across the barrier set there to prevent cattle
wandering.

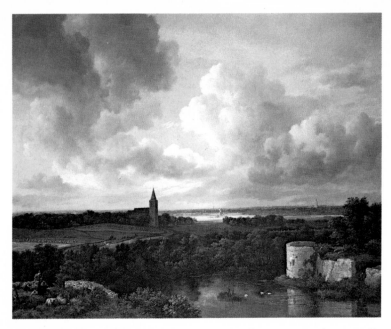

others and give an impression of being very bright and acid. Yet others are gentle and almost grey. In fact, there are a lot of greys in landscapes, and these are not always made by mixing black and white.

Skies and Clouds

An interesting sky, which is not always a busy sky, can be a vital part of a landscape. The light and colouring in a landscape depend entirely on what is happening in the sky. Most people know how the sky can change dramatically on one of those bright showery days when great clouds racing overhead sometimes expose the full force of the sun and create strong lights and shadows and warm golden colours: the next minute they cast the whole into a dark similarity. On a large landscape, there are times when one part of the land is bathed in light and other parts lie in the dark shadow of enormous clouds.

The artist has to be quick in situations of this kind, either trying to capture the dappled effect at the expense of some precision and detail, or else choosing one light or another and waiting for its return. One way of coping with the large rounded masses of cloud is to adopt the following procedure:

1. The colours of the clouds are mixed up without reference to any precise cloud. It will be seen that the clouds consist of a light and a dark side, and have the blue of the sky mixed up in them as well.
2. The direction in which the clouds are moving across the sky is noted.
3. An interesting group of clouds is chosen, and drawn in as quickly as possible. Then they are painted

Jacob van Ruisdael: An Extensive Landscape with a Ruined Castle and a Church *(Oil). Such a sky as this could only come from a great knowledge and love of clouds. Beginners often paint the land, and leave the sky until afterwards—or until they get home! But the light in the sky at the time the painting is being made is what gives the land its appearance, and the two cannot be separated. Ruisdael often painted his landscapes from so low down that the sky takes up even more space than it does here, where he is looking down from a hill.*

with the colours that have already been mixed, modifications being made where necessary. There should be time to follow the group of clouds across the sky; and although they will change shape somewhat during their passage, their basic identity will remain the same.

Several types of massed clouds catch the light and have shadows just like other objects—like boulders and trees, for example. The drawing and painting of clouds can be practised by arranging 'clouds' of cotton wool. But the light and dark on clouds is not so crisply modelled as on a heavy substance such as rock, and the effect is altogether gentler; clouds should not be painted in too modelled a fashion. The 19th-century writer on art John Ruskin described clouds as 'sculptured mist', and that is probably

J.M.W. Turner: House, Probably near Abingdon *(Water-colour). If a painting is started in sunlight, the painter needs to remember that what is in bright light in the morning may well be in shadow—and a quite different colour—in the afternoon. Some painters get round this difficulty by making one sketch in the morning and another in the afternoon; others try to achieve consistency simply by remembering what the light was like when they began painting. The important thing is to keep the shadows the same. In this early painting Turner seems to have gone wrong. The shadows appear to have been added later.*

a good and useful way to think about them.

Some types of clouds are more wispy and wraith-like. It is better to try to get their colour right, rather than worry too much about their shape.

All clouds, including the larger ones, have a 'frilly' edge that is difficult for the painter to capture, however delicately brush and pencil are handled. The edge is not sharp like that of trees or grass but is a firm yet soft line.

Reflections

Painting water is a wonderfully calming experience, especially on a still day when the reflections stay untroubled. Three considerations are helpful:

1. Reflections must be painted rapidly; they change as the sky changes.
2. Reflections are simply what is seen on the bank, upside down and broken across by disturbances of the surface of the water—caused by ducks, boats, or the breeze. Often, they are patterns of colour almost as if they had already been painted by an impressionist painter. Depending on the light and on the colour of the water, some reflections are nearly as bright as the things they reflect.
3. It helps to try to see reflections as being flat shapes of colour, rather than to worry about the fact that they are reflections. There is no gimmick or secret involved in painting reflections, other than trying to look at them hard and paint them as they are.

Still Life

One of the best reasons for painting is to make a likeness of something that is loved or admired. And that is why so many artists in all ages have made paintings of still life. To call such paintings 'still life' makes them sound rather dead—and indeed the French call them *nature morte*—but it is because they are still that the beginner can learn so much from them. There is not the problem of changing light as there is in landscape; nor is there movement as there is in the case of portrait and figure painting.

If a painter's opportunities for working consist of short periods spread out over a week or so, a still life to paint can be set up in a corner of a room and left there as long as necessary. But if, after a bit, it is found that this very permanence leads to monotonous results, and a sense of urgency is needed for a painter to produce his best work, then the still life can be composed of such things as fish, flowers, and fruit which must, of course, be painted speedily.

It is this great range of possibilities that makes still life such a marvellous subject. And it can also be used as a way of discovering about painting, because it lends itself to concentration on individual aspects of the art.

There are two main ways of setting up a still life. First, a collection of objects can be put down at random, and just painted as they are. Second, objects can be carefully selected for their colour or shape, and spaced so that they make a particular composition.

The Accidental Still Life

This way of setting up a still life depends more on accident than design, and it is amazing what a variety of beautiful shapes can be displayed by a group of objects arranged at random. Of course, a certain degree of selection is involved, since the artist has chosen to paint a group of objects that has caught his eye. The point of attraction may be the combination of colours, the shape, or even the surroundings. Often a stone or shell on the beach loses its attraction when brought home away from its original background. The group should be left where it has been found, and the painting started. This may require the painter to hang over the cooker or work in the bathroom!

The Composed Still Life

In composing a still life, the artist has to consider more carefully what he wants to paint. The painter Bernard Dunstan remarked that things that are enjoyable to eat are often the most enjoyable to paint, and there are certainly many paintings that suggest that this is true. A very wide range of ideas is available to the still-life painter. It is possible to illustrate a variety of things that have great sentimental meaning, or simply to explore the relationship between the orangeness of oranges and the greenness of an apple. Again, the aim may just be to illustrate one thing—a particular cup or a fish—or a whole jumble of objects and materials, as the painter Cézanne often did.

A person beginning painting needs practical and definite advice about

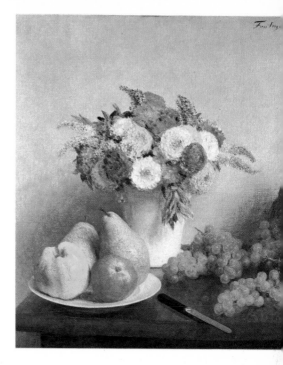

Henri Fantin-Latour:
Flowers and Fruit *(Oil).*
This still life has evidently
been carefully arranged
and thought out. All the
colours are in the warm
range—yellows, oranges,
reds, and browns. There
is a small amount of warm
green, and only the wall
behind is cool. The fruit
and flowers seem to be
arranged in three groups of
pyramids; the angle of the
knife emphasizes their
triangular shapes.

Overleaf: Edouard Vuillard:
Mantlepiece *(Oil). Vuillard*
delighted in painting rooms
cluttered with objects. He
loved the dappled effect of
colours in such a setting.
It is unlikely that this view
was organized: but a
flower may have been
added, a bottle moved to
the left.

setting up a still life. Composition, like everything else in painting, is not immutable: what one generation of artists accepts as law is broken successfully by another generation. That fact must always be borne in mind, but some practical suggestions are possible.

Colour

Too many different colours in a still-life arrangement may bombard the eye and lead to a confusing painting. There is no need to have everything in every painting. A painting showing red peppers, green peppers, aubergines, lemons, plums, and a blue tablecloth would be exhausting to look at—and extremely difficult to paint. Cézanne, who took a long time

to compose his still lifes, treated the actual selection and arrangement of the objects as if he was making the painting. He may even have taken several days in deciding on the composition. Often he would have several bright orange colours and the warm browns of a table balanced with cool greys and blues in other objects. There would also be a white cloth or white plates. These white objects would probably reflect the oranges and the blues in addition to providing a sparkle in the painting. The whole would depend on the harmony of oranges and browns with the blues and greys. A similar harmony could be achieved with reds and greens.

Too many bright colours can assail the eye in an unrestful way, and it is

probably better to limit them. Some of the most colourful paintings of the past, when analysed, are seen to have only a little glowing colour; but all the gentler, milder colours help to build the glowing colours up and give them their intensity. A painter who likes brightly coloured objects must resist the temptation to put them all into one painting.

Arrangement

When the objects to be painted have been assembled, they should be spread out. Many still-life paintings in which the main objects are huddled in the middle of the canvas have an artificial look. The large areas of leanly painted background seem to swallow them up. Of course, there are some great still lifes in which the objects are in the middle; and this can sometimes work when done intentionally and with skill.

It is quite permissible for some things in a painting to be only half shown, with part of a saucer or bottle actually going off the canvas. And when the objects have been set up, there is no law that says they must all be put in. At that stage, the painter may decide that only part of the arrangement is really interesting and may concentrate on that.

How Many?

The simplest still-life painting uses just one object. Two objects are more difficult to place in a pleasing way because they can seem to halve the picture. Putting one of them partly off the painting or in shadow can help.

With larger groups of things, one object can be made to dominate the rest as in the painting by Cézanne on p.30, where the water jug is the major object. But there are other

possibilities, such as scattering various objects of similar size around to make a pattern.

Surroundings

In a finished painting, the areas of table, wall, or cloth visible around the still-life group have as much importance as the things themselves. They, too, are areas of colour, and the painter must not treat them as being less important than anything else. So he must take trouble to use colours for them that work in with the rest of the painting.

Light

If the still life is strongly lit, dark shadow patterns will be cast. They may provide beautiful shapes that will contribute to the composition. The group can be arranged very effectively so that some parts are well lit and others are in shadow. But if the painting of this sort of arrangement begins in daylight and continues in artificial light, the painter must be aware that both colours and shadows will change with the change of light.

Preliminary Drawings

Many artists find it useful to make preliminary drawings before they start painting. These drawings need only be quick notes, but sometimes a useful thought occurs—perhaps about arrangement or colour—that is later lost unless noted down.

Viewpoint

A still life group is often arranged on a table; but placing the objects on different levels may provide a more interesting viewpoint. Van Gogh used his chair when painting his candle; Bonnard would even open a kitchen

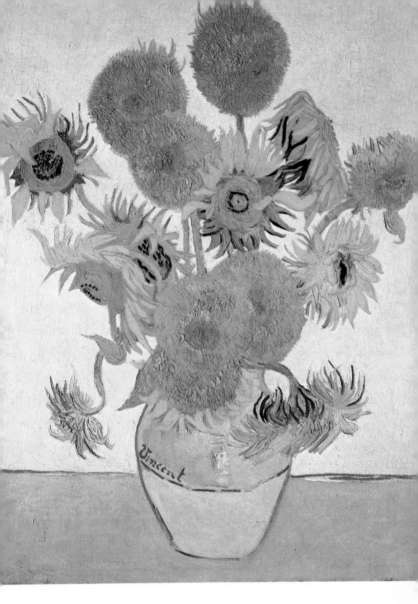

Vincent van Gogh: Sunflowers *(Oil).
No reproduction can give the impact
of the colour in this painting, though
in reality the amount of pure colours
in it is small. Much of the painting is
made of ochres and gentle browns.
Van Gogh has arranged the flowers so
that their shapes make beautiful
silhouettes, and there is careful
balancing of the picture.*

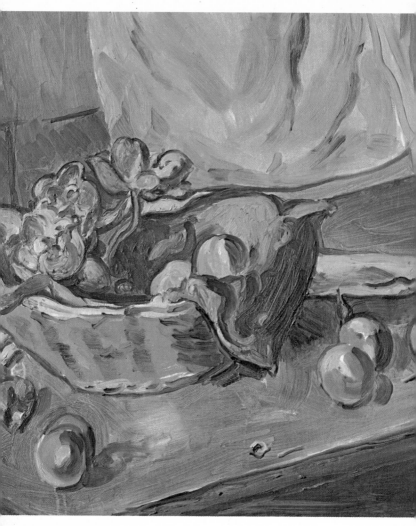

cupboard and paint the contents of all the shelves.

Colour Practice

A useful exercise to occupy a few spare hours is to collect together a variety of objects of the same colour family and paint them. For example,

tomatoes, red plums, a rose, an earthenware flower pot, and a red scarf could be arranged together and painted with the idea of exploring a variety of mixtures of one colour. Still life can be used in this way to study a particular aspect of painting technique.

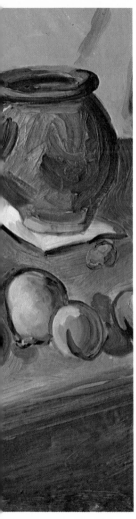

Above: Matthew Smith:
Still life *(Oil). In this
painting, the pattern on
the bowl has been
observed as carefully as
the fruit, and has clearly
been a vital part of the
design from the start—not
an added extra.*

Below: Jacques Le Moyne de Morgues: A Pear
*(Water-colour). One of the best and oldest reasons
for painting is simply to make a record of
something that interests you, whether it be the
play of sunlight on water or the colours and
texture of a pear.*

AM326㲋 -'56.

Portraits

Self-portraiture is a good way to learn about portrait painting. It has many advantages; the sitter is always available when the artist is ready to paint; it is not difficult to persuade the sitter to remain still; and the result, if unflattering, affects nobody but the painter!

It is best, probably, to begin with a full-face portrait—looking straight at the mirror and concentrating on the head. The whole head and shoulders should be drawn in first, every effort being made to get the distances between the features right. The relationship between the top of the eyebrows and the tip of the nose, for example, should be carefully assessed, because the reproduction of such proportions is what gives a likeness.

No individual feature should be developed in detail until it has been properly placed in its relationship to the rest of the head. For example, until it is certain where the eyes come in a portrait, the iris, the eye lashes, and so on should not be painted. Otherwise, though the eyes may be drawn very beautifully, they may be in quite the wrong place.

However it is helpful to choose a certain area and try to work out all other proportions from that, once the initial drawing of the whole head has been made. If, for instance, the painter begins at the bridge of the nose, he could note where the top of one eye comes and relate it to the top of the other eye. Then trying to forget all he knows about eyes, he might observe how this particular one slants down at certain points.

Then he could line it up with features above or below it. Is its highest point immediately above the edge of the lips, perhaps?

What Lies Beneath?

Children tend to think of the human head as consisting mainly of eyes, nose, lips, and ears. But to depict the head convincingly, the painter must be aware of many other features.

Anatomically, the shape of the head and body depends on what lies under the skin; that is on bone, muscle, and fat. Sometimes what is most apparent is bone. This is true of a person's jaw, and usually of the bridge of the nose and the edges of the forehead.

Muscle conditions the shape of the area around the eyes, the lower part of the nose, and, depending on the thinness or plumpness of the face, the cheeks, the setting of the mouth, and the neck. In some faces, the fat under the skin is more important. It softens and rounds the cheeks, the chin, and the area around the eyes.

These underlying differences are emphasized by the fall of light, which gives the face its shadows. Some shadows are strong: for instance, those under the eyebrows and under the chin, where the bone is revealed. Other shadows are gentler and less easy to distinguish—in the area between the nostril and the ear, for example, where the bone lies beneath thicker layers of fat or muscle.

Using a Sitter

When the beginner has tried a self-portrait, and gained some confidence

Stanley Spencer: Self-Portrait *(Oil).*
This is an intensely observed study of
the head. The artist has placed
himself in such a position that the
light pours onto the left side of the
face leaving the other side in shadow.
The way that dark shadows turn into
the light is described with great
exactitude.

about painting a head, it is time to try painting a portrait of somebody else. But it is important to have a sitter who does not expect a masterpiece and will not be offended by the result.

The sitter must feel comfortable. Usually, a person taking up a pose for the first time adopts an artificial position. If this happens, the painter should talk for a while, and perhaps do some incidental drawing until the sitter relaxes into a more natural pose.

Three-quarters of an hour is generally long enough for each spell of work between rests. Some sitters may not be able to hold a pose for as long as this. Sometimes, conversation assists in keeping pose natural; at other times, talk is a hindrance. Music or the radio can help if the sitter is bored, and if children are being painted, a television set may keep them entertained. In general, as soon as a sitter begins to look bored, there should be a rest—unless what the painter wants is a sullen expression!

Pose and Lighting

A portrait may consist of the head and part of the neck; or of the head and shoulders; or of the head and body down to the waist; or of the whole length. In each case, the position of the head is very important, whether it is full face, or a three, quarter view, or a profile.

It will probably be necessary to experiment with the lighting in order to get the desired effect. Ideally it should help to show the nature of the sitter, but if not used skilfully it can have the opposite effect. A girl with a very soft complexion, for example, may not be set off well in strong light which cuts her face up

into sharp areas of colour.

The lighting may come from one source—a window or a lamp—and will have different effects depending on whether it is in front, at the side, above, or below. It may be useful to experiment with two sources of light, and it is worth spending quite some time setting up the model, and making sure that the light comes from the

Problems in Portrait Painting

A child often draws a head as a round or oval shape, with the eyes, nose, and mouth filling the whole area. What the child forgets, or does not see, is that the area of the face is only one part of the head. If a skull is studied it will be seen that there is a considerable amount of head above the eyes, and in a living figure there is hair to be added as well. So it is important to give the top of the head the right amount of space.

Painting and drawing hair can cause some difficulty. The beginner is tempted to scribble it in quickly to give a general effect; but the hair is as important as the features, and should be treated carefully and drawn accurately. Firstly, the artist should try to make out where each clump of hair originates. Certain strands or waves of hair will have stronger shapes than others; and the light will fall differently on some parts of the head, making some areas of hair dark and others light. Items such as spectacles and jewellery should be treated as an integral part of the portrait, and not added afterwards as an afterthought.

Beginners sometimes have difficulty in mixing the right colour for skin tones, and end up painting rosy, blushing cheeks which seldom exist in real life. Rather than mixing red and white together, the artist should try mixing yellow ochre and white; other colours can then be added to get exactly the right colour. It is important to remember that flesh reflects colours around it—blues and greens and many shades of grey can be found on flesh.

The artist should be careful not to over-emphasize the colours of individual features. Lips are rarely a simple bright red patch. The various parts of the lips are made up of different colours. The crack between them is usually the darkest part, and the rest is more of a brownish red which changes colour as the light falls on it. As far as the eyes are concerned, the 'whites' are more grey than white.

It is as important for the artist to capture the personality of the sitter as it is to create an accurate or photographic likeness. The surroundings and placement of the sitter play a large part in this. The surroundings should suit his character. For example, a businessman would probably not feel happy about having his portrait painted in a kitchen, and, similarly, a young child would probably object to being asked to sit still on a hard chair in a bleak room.

Many portrait painters have a problem with the time available to paint a portrait. The sitter may be a busy person who cannot spare hours on end; in this case, photographs may prove useful for the artist to work from.

right direction and is of the right intensity.

Surroundings

The colour of the background is important: rather than adding something in later, it is better to place the sitter in front of material that seems to bring out the sitter's colouring, and that enhances the clothes being worn. The painter may also want to include other objects in the picture, as in the portrait of Lytton Strachey by Henry Lamb. A favourite pet or familiar possessions may encourage naturalness in the pose.

Getting a Likeness

In practice, it is best to forget the idea of getting a likeness. Sometimes, the initial drawing looks very like the subject; but then the likeness is lost as the painting progresses, only to return eventually. The portrait painter's best formula for success is to concern himself with trying to get things the right colour in the right place—as he would if painting a landscape or an apple.

There is no special secret in portrait painting; the process is exactly the same as for other subjects. But if the painter is interested in people

Right: Edouard Manet:
Eva Gonzales *(Oil).* In
this painting, Manet has
considered the background
as carefully as the sitter.
Eva Gonzales was a pupil
of his. He has used the
shape of her dress in
striking silhouette of light
against dark.

Left: Joshua Reynolds:
Lord Heathfield *(Oil). A*
portrait that places the
sitter in his natural setting
is always more interesting
than one that has been
artificially composed for
effect. This painting
recollects Lord Heathfield's
defence of Gibraltar
throughout its longest
siege. The key of Gibraltar,
the column of smoke, and
the cannon symbolize the
event. Contemporary dress
is seldom as interesting to
paint as some of the
splendid uniforms of the
past.

and the human face, this interest obviously helps. Being sensitive to the sitter and yet politely firm about getting back into the same position after a break can help the painting along. Getting the sitter to look intently at one particular object when the pose is first adopted makes it possible to get the head in the right position again after a break. Sometimes it is wise to mark where the feet or hands are with chalk.

Adverse criticism of a portrait while the work is in progress should not worry the painter. The human head has, in a relatively small area, features that are capable of an infinite variety of moods or expressions of character. If a leg is a little too long, it is probable that no-one will remark on it; but if the corner of a mouth is accentuated a fraction too much, then the entire character of the face may be altered and everybody will see it. But, often, the smallest brush mark will change that.

The painter must remember not to fasten on to a particular feature, such as a group of eyelashes, at the expense of the whole face. It is more often the posture and larger characteristics of the face that give the likeness. Few of us recognize people by the number of lines around their eyes—it is more the way they carry their heads at a slightly upturned angle, or the way the cheeks dip around the mouth.

Imaginative Painting

All painting involves the imagination, but some paintings are purely imaginative. A painter who is accustomed to drawing and painting objects that are in front of him, may well be discouraged when he comes to describe a memory of a scene or situation, or to put into paint an idea or a dream. He will be forced to a realization of how little he knows of the way things look and work. It is likely that his figures will be clumsy and will not stand on the ground convincingly. Trees and skies will not be realistic.

Imaginary Realism
It is hard to produce realistic pictures straight from the imagination, and most artists find that if they want to paint such pictures they need to have studied for some time how things look. In the past, the study of anatomy and perspective was a vital part of a painter's education; many artists could compose a painting that looked almost as if one could step into it and join in with whatever was going on.

The best approach is to try to paint the idea, and, then, if some things in the picture do not look right, to go out and try to find a real-life example that can be copied. If what has gone wrong is, say, the particular way that a figure is standing, or the way a hand clutches a sword, then the painter has either to get a friend to model the action or draw himself in a mirror. Trees and landscapes are no great problem because they are normally within reach, and animals can be studied in a zoo or perhaps in a museum.

'Symbolic' Painting
Another way of painting from imagination is not to worry about making things look real—not to strive after correctness of perspective or anatomy—and to describe things more simply, almost as symbols. The mediaeval painters worked to a large extent in this way, and throughout history it has always been an important part of art.

If one character in such a painting

Right: Marc Chagall: Maternité (Oil). The laws of gravity, scale, and natural colour do not apply to Chagall's figures that float in the sky around the long-legged woman with the green face and the child in her womb. This work is not 'realistic' like the painting by Dali on the next page, which, although you would never come across its counterpart in reality, is described in an almost photographic way. Chagall believed that reality had different levels. A person looking at a mother and child does not necessarily register mentally a mere photographic view. What he sees may be coloured by emotions generated by the ideas of 'motherhood' and 'childhood'.

Left: Rashid-al-Vins Janii-al-Tawarikh: Jonah and the Whale. The painter studied the sea and the way it behaved in a storm; but described it symbolically by using wild and irregular patterns for the waves. The design, with the fish curved round, conveys in a direct way the drama of the situation. His approach can be contrasted with that of Turner, who also spent much time studying the sea, but described it in so realistic a way that the viewer could imagine himself actually there.

is more important than the rest, then he might be made larger—regardless of where he is in space. If the painter likes ornament and pattern, this can be a lovely way to paint, for he can concentrate more on the shapes of the leaves on a tree or the pattern of bricks in a wall than on their perspective. He also has great freedom in using the colours he likes.

All painting stems from observation—from looking at and drawing what exists. The imaginative painter usually finds his eyes being drawn to look at the patterns in nature; the way things grow and arrange themselves. Trying to paint a face, however symbolic the painter wants it to be, leads him to looking at faces with a more inquiring eye. Rather like a novelist, he finds himself acquiring a range of facial expressions, of characters, of patterns, and of episodes to paint; keeping a sketch book of these can be invaluable.

Notes about colours can be written on the drawing, with any description that will jog the painter's memory later on: trees the colour of the walls in the bathroom at home; sky broken up with the colours of very weak milky tea; reflections of a boat the colour of red wine; and so on. If there is time, some actual patches of colour on the drawing will be a great help when painting later on.

Salvador Dali: Soft Construction with Boiled Beans: Premonition of Civil War *(Oil). To be able to distort a figure and to heighten natural colour convincingly, as Dali has done in this painting, requires a good understanding of the structure and appearance of things in reality.*

Abstracts

Someone once said that when a sculptor is carving a figure from a block of marble, he is abstracting or removing all the material that hinders the vision the marble conceals. By that abstraction, he brings to light the hidden beauty.

This is quite a helpful way of seeing abstract art. It is an attempt to select the essential—the essence—of what we see. When people look at abstract paintings they try to 'see' something in them. In a gallery of modern art, people will be heard saying that a painting with three black stripes 'looks' like railway tracks—that is what it suggests. Other abstract paintings may be easier to pin down: the subject of one may, for example, obviously be a figure or a still life that has been simplified in an attempt to find its essentials.

In this respect, every painting an artist makes, however realistic it may be, is an abstract painting. For when we look around, what we see is so complex that it is impossible to paint it exactly. An artist painting a tree, however carefully and successfully he describes it with brush and paint, will always have to choose to leave out some bits and simplify others. He will be, even though he may not be aware of it, selecting certain things to look at and ignoring others—in fact abstracting.

There are, generally speaking, two ways of going about producing an abstract painting. The first is for the painter to begin in the normal way with a subject that is in front of him, and to draw and paint it very carefully as it is. Then, in other studies, he attempts to remove what he considers to be the inessentials, and refine it to its basics.

The other way is to begin by drawing lines and putting on bits of

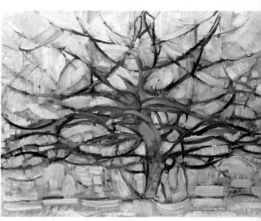

These three paintings in oil by Piet Mondrian demonstrate one approach to abstract painting—that of starting by painting an object realistically, and then arriving at its essence by a process of much looking, understanding, and feeling.

The Rode Boom *(Red Tree), below left, was painted as a direct study. Its shape makes it an energetic and powerful composition. The* Gruze Boom *(Grey Tree), above right, painted shortly afterwards, shows a similar tree simplified in a way that describes its structure and the pattern of its interlaced branches. The tree is, perhaps, less important than the pattern it makes. The* Blodelende Appelboom *(Flowering Apple Tree), right, which was painted still later, explored the tree's structure even further. When the shapes in a design give an impression of beauty they usually correspond to nature.*

colour, trying to balance them against each other like making a house out of playing cards. They are kept just as lines and blobs of colour, and the painter does not try to read anything into them at this stage.

In this sort of painting, the picture is created not from recognizable objects, such as horses and trees, but from more basic elements such as circles and lines. The way they are organized on the paper or canvas, the way one area of colour is placed next to another, will create certain feelings and harmonies—or disharmonies. Vertical and horizontal lines can seem more calm and restful than lines that slant diagonally across the painting.

The painter Paul Klee worked rather in this way. And he found it important to be in a trance-like state as he worked so that the arrangement of lines and shapes grew from his deepest level. Often, when the painting was finished, it would resemble something recognizable and he would at this stage give it a name.

Framing

The question of framing pictures has to be faced by the painter sooner or later, whether it is being done for the painter's own satisfaction, or for exhibiting or selling, or because a painting is being given away as a present.

Most oil-paintings and acrylics look well in simple wooden frames. Water-colours, pastels, gouache, and drawings need to be put behind glass for protection. They are surrounded with borders of white or coloured card and are normally given gilded or plain wooden frames.

A useful tip when at exhibitions is to study attractive frames and write down the kind of colouring and proportions used. Good frames should never attract attention to themselves; their job is to complement the painting and present it at its best.

Professional Framing

There is a considerable art in framing pictures and, like artists, picture framers can vary in imagination and skill. Ideally, every picture should have its own frame made up for it; particular colours will suit particular paintings. But having picture frames made is expensive, and many painters —at first, anyway—buy ready-made frames.

For oil-paintings, the simplest of wooden frames is preferable to synthetic gold. Wooden frames can be left plain, or can be lightly polished or painted.

Home-Made Frames

Some painters make their own frames, but a knowledge of woodwork is required. A good idea is to take an old frame to pieces and study the way it is put together. But for anybody who enjoys making things and who does a fair amount of painting, being able to cope with framing saves quite a lot of money. However, certain items of equipment are necessary; a mitre board—the metal kind that holds the pieces in position for sawing, glueing, and nailing; a tenon saw; an accurate ruler; a hammer and small nails; fine sandpaper; and woodworking adhesive.

Renovating Old Frames

Old frames are becoming ever more expensive, but good ones can still be found in junk shops, at jumble sales, and in street markets. Generally, they look battered, the gold is patchy and the moulding damaged; but they can often be remodelled. Sometimes when the moulding is soaked off, a beautiful plain wooden frame is found underneath. If a frame has been painted, paint stripper may reveal something more promising. The thin water-colour frames are often the most useful. If the glass is missing, a new piece can be cut to size, and a fresh mount made.

Mounts

A mount, or *mat*, is a piece of cardboard (of a type called *mounting board*) in which a window is cut for a drawing to show through. The mount forms a sort of frame within the frame proper. This is done to give the picture 'room to breathe'—if the actual frame comes immediately on

the edge of the painting, it seems to cut it off abruptly.

But pictures can look good just in mounts—that is, without a real frame —and some exhibitions will accept work in this state. Obviously, the mount does not protect the painting, which must eventually be put behind glass and sealed from the back to prevent damp and dust getting in.

The edges of the mount are bevelled —that is, cut at an angle that slopes inwards towards the painting and helps to let the painting flow into the mount.

Cutting mounts takes a bit of practice, and it is best to follow precise instructions from someone who knows about it or from a book. The choice of colour of the mount is important, because this can enhance the painting or work against it. It is advisable to try various colours of mount against a painting before deciding which to use; usually, the gentler colours are more effective.

Some pictures look well in ornate frames; others demand a more simple style of framing.

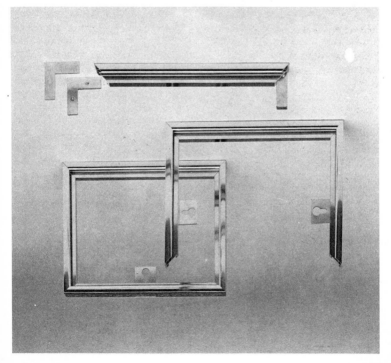

Glossary

Abstract painting A form of painting that represents the essential idea by abstracting detail from what the painter actually observes.

Acrylic paint The most recent development in artist's colours, acrylic paints dry rapidly. They are ideal for paintings that need large, flat areas of colour and neatly-painted edges. But because they harden quickly, they also have obvious disadvantages.

Alizarin A coal-tar dye used in the manufacture of certain pigments, such as Alizarin crimson.

Alla prima Oil painting accomplished in one layer of paint, without any underpainting. It is the normal method of oil painting today.

Binder A constituent of paint. The binder, which is usually liquid, is mixed with pigment in powder form to 'bind' it together and form a usable paint.

Bloom Discoloration of varnish or certain paints. Usually, it does not seriously affect the painted surface, and can be easily removed.

Burnishers Polishing tools used in frame-making and various printing processes.

Cadmium Pigment prepared from cadmium salts. One of the most frequently-used cadmium colours is cadmium red.

Canvas Textile surface used for oil-painting.

Chamfer In frame-making, the bevel at a right-angled corner.

Charcoal One of the oldest drawing materials, consisting of burnt wood.

Chiaroscuro The use strong contrasts of light and dark in a painting.

Cobalt Is a silver-white metal which is the basis of various pigments. The best known are cobalt blue, coeruleum blue, new blue, cobalt yellow, and cobalt green.

Complementary colours The complementary colour of each of the primary colours is that formed by mixing the other two primary colours. For example, the complementary colour of red is green: red is a primary colour, and green is composed of the other two primary colours, blue and yellow.

Composition The way in which the various elements of a painting are put together.

Conté Crayons made in Paris by the firm of Conté. They are more closely textured than charcoal, and are sensitive to the grain of the paper. They are made in four colours: black, white, sanguine, and sepia.

Cool colours The colours that are generally thought of as cool and restful; chiefly blue, green, and violet.

Cross-hatching A form of straight line shading in which the lines cross each other to give a greater impression of density.

Earth colours These are pigments derived from inert minerals. They include the ochres and umbers, and are generally long-lasting.

Easel An adjustable support for the board or canvas on which the painter is working. Portable easels are available for sketching out of doors.

Emulsifier A substance that enables oil and water-based materials to be combined for use as media. An example of such a medium is tempera.

Fat A term used in relation to paint, indicating that it has not been diluted with turpentine and is consequently thick and oily.

Ferrule The metal band on a paint brush that holds the hair or bristles.

Figurative painting Not merely painting in which figures appear, but also, in a general sense, any painting that is not abstract.

Filbert A shape of brush. A cross between flat and round, filbert brushes taper broadly to a point.

Fixative A substance sprayed on the surface of pastel and chalk paintings to protect them, and prevent smudging.

Foreground The area immediately in front of a landscape painter.

Foreshorten The representation of an object in shortened perspective.

Fresco A painting in water-based pigments on a lime-plaster wall or ceiling. Though many frescoes still exist that date from classical times, they reached their highest point of development during the Renaissance.

Gilding The application of gold leaf to

a surface. Generally used in frame making. It has also been used to illuminate paintings.

Glair Tempera made from white of eggs.

Gouache A waterbound paint made with the same binder—gum arabic—as water-colour, but with white pigment added. Gouache is more opaque than water-colour. The texture is very fine, and gouache paints can be used with soft brushes, bristle brushes, or an air-brush.

Graphite A form of carbon; it is used in the manufacture of pencils.

Gum arabic A natural substance exuded by acacia trees. It is a binder used with water-soluble pigments.

Hatching A form of straight-line shading.

Impasto The application of paint thickly to a surface.

Indian ink A carbon-based black ink valued for its fluidity and density.

Ingres paper A soft textured paper used mainly for pastel and water-colour work. It is made in various colours.

Iron oxide A constituent of many pigments, particularly red and yellow pigments.

Kolinsky Hair used in fine sable brushes. It comes from the Siberian mink.

Landscape painting Painting of natural scenes. Landscapes are among the most popular subjects for painters.

Lapis lazuli A blue gem-stone once ground up to make blue pigment.

Lean A term used in relation to paint, indicating that it contains only a small proportion of oil.

Linseed oil The most common binder for oil paint. Though it dries quickly, it retains a degree of flexibility for many years.

Medium In painting, the word has two meanings. It may refer to the type of paint used: for example, oil paint is a medium, water-colour is a medium. Or it may refer to the liquid used to dilute paint to make it easier to apply. An example of a medium in this second sense is turpentine.

Middle distance The area in a land-

scape between the foreground and the horizon.

Mount A border round a painting, separating it from the frame.

Ochre Inert minerals used to make pigment.

Oil paint A pigment ground in an oil-based medium, such as a mixture of linseed oil and turpentine.

Opacity The ability of a paint to cover a surface in such a degree that the surface does not show through.

Palette The wooden, glass, or metal surface on which a painter mixes his colours. The three commonest palette shapes are oblong, oval or hook shape, and kidney or studio shape.

Palette knife A knife with a flexible blade used for mixing paint, and sometimes for applying paint.

Pastel Powdered pigments bound together with gum or resin. They are made in sticks and share some of the qualities of water-colour and oil paint. They are valued for their purity of colour.

Pencil One of the most versatile and sensitive drawing instruments. Pencils are made in a wide range of hardness and softness.

Perspective The representation of an object or a scene on a flat surface in such a way as to give a three-dimensional effect.

Pigment Dry paints that are mixed with fluid such as oil or water to give a medium suitable for painting with.

Portrait painting Representation in painting or drawing of the human figure, or part of the human figure. Many artists have made self-portraits.

Render To prepare a surface for painting.

Resins Natural substances exuded by coniferous trees, used in making mediums. Synthetic resins are now in common use.

Sable An animal whose hair is used in making the best quality of soft brushes.

Scumble The application of a thin layer of paint over a more intense layer.

Shading Methods of indicating shadows or other dark areas in painting or drawing.

Shellac A substance used in making

varnish. It is obtained from the lac insect.

Still-life A form of painting in which the subject is composed of a group of inanimate objects.

Stipple A method of drawing using series of dots instead of lines.

Tempera Painting media consisting of emulsions of oil and water. Generally, the term refers to an egg emulsion.

Tint A pure colour to which white has been added.

Tone The degree of darkness or lightness of a colour or a patch of shading in a drawing.

Turpentine The diluting medium used in oil painting.

Ultramarine A blue pigment made from lapus lazuli. Today a synthetic pigment called *French ultramarine* is used in its place.

Warm colours The colours that are generally thought of as warm are red, orange, and yellow.

Water-colour A pigment mixed with water-soluble gum. Water-colours are applied to paper with soft, moistened brushes, and have a semi-transparent appearance.

White Spirit A turpentine substitute that can be used for diluting oil paint and washing brushes and equipment.

Practical Hints on Painting Outdoors

Seat A comfortable seat is important. It is better to have materials and equipment that help rather than hinder, and being comfortable makes it possible to concentrate just that bit more. Collapsible chairs with arms are not suitable, because the arms tend to get in the way of the brush or drawing board, and it is difficult to sit on them without slumping back. The smaller metal chairs with a back are good. But 'sketching stools' that fold up into a very small size are usually most uncomfortable.

Easel For oils and pastels, the larger water-colours, and gouache, an easel is essential. The light wooden or metal sketching easels are practical to use. The various types can be tried out in an art shop. The more rigid they are, the better. Easels that have a box fitted to them are extremely useful for landscape painting in oils, but they are expensive.

Hat A hat with a brim is a practical necessity for painting in the sun. It is easy to forget how strong the sun is when painting becomes absorbing.

The Light On a sunny day, the sun moves and the light changes. In the afternoon, a painter may find that what was in shadow in the morning is now in direct light. A sensible approach is to work on one painting in the morning and on another in the afternoon. Both can be continued on the following day.

Preserving the View The painter's view can change suddenly unless he has chosen his spot with care. In a village street, a lorry may park directly in front of the subject the painter is working on. Or a field that was empty before lunch may have a herd of cattle in it after lunch. In the latter case, a word with the farmer before setting up the easel would probably save a lot of heartache.

ACKNOWLEDGEMENTS

The author and publishers wish to thank the following for their kind help in supplying photographs:

Page 8: Narodni Gallerie, Prague. Page 9: The Armand Hammer Collection. Page 15: Courtesy of Fogg Art Museum, University Bequest Grenville L. Winthrop purchase — Friends of Art and Music at Harvard. Page 16: Los Angeles County Museum of Art. Page 19: Museum of Modern Art, New York — Abby Aldrich Rockefeller Bequest. Page 28: National Museum Vincent Van Gogh, Amsterdam. Page 29: Tate Gallery, London. Pages 30/31: Tate Gallery, London. Page 32: Giraudon/Musee National D'art Moderne. Page 33: National Gallery. Page 34/35: National Museum Vincent Van Gogh, Amsterdam. Page 40/41: Fitzwilliam Museum, Cambridge. Page 43: British Museum, London. Page 44/45: A. C. Cooper/Victoria & Albert Museum. Page 46: A. C. Cooper/Victoria & Albert Museum. Page 47: National Gallery. Page 48: Tate Gallery, London. Page 51: Tate Gallery, London. Page 52/53: c David Hockney 1967 Courtesy Petersburg Press. Page 55: Bulloz/Petit Palais, Paris. Page 56: Service du Documentation/Louvre. Page 58/59: Philadelphia Museum of Art. Page 60: c David Hockney 1973 Courtesy Petersburg Press. Page 62: Fonds Albertine, Italy. Page 64: British Museum, London. Page 67: Baltimore Museum of Art. Page 68: British Museum London. Page 69: Rijksmuseum-Stichting, Amsterdam. Page 70/71: Ashmolean Museum, Oxford. Page 72/73: Top Collection State Museum Kroller-Muller-The Netherlands. Bottom, National Gallery. Page 74: Ralph Kleinhempel/Hamburger Kunsthalle. Page 76: Rijksmuseum-Stichting, Amsterdam. Page 77: Musee Marmottan, Paris. Page 78: British Museum. Page 80: J. Webb/Tate Gallery, London. Page 81: National Gallery of Scotland. Page 82: National Gallery Prague. Page 83: National Gallery, London. Page 85: Tate Gallery. Page 86/87: A. C. Cooper/Victoria & Albert Museum. Page 87: Top, National Gallery, London. Page 88/89: Victoria & Albert Museum. Page 90: Royal Academy. Page 91: Service du Documentation/Louvre. Page 92: National Gallery, London. Page 94/95: British Museum, London. Page 97: Service du Documentation. Page 98/99: National Gallery, London. Page 101: National Gallery, London. Page 102: J. Webb/Tate Gallery, London. Page 103: A. C. Cooper/Victoria & Albert Museum. Page 105: John Webb/Tate Gallery, London. Page 106: John Webb/Tate Gallery, London. Page 108: National Gallery, London. Page 109: National Gallery, London. Page 110: Edinburgh University Library. Page 111: Collection Stedelijk Museum, Amsterdam. Page 112/113: Philadelphia Museum of Art — The Louise & Walter Arensberg Collection. Page 114: Collection Haags Gemeentemuseum — The Hague. Page 115: Top & Bottom, Collection Haags Gemeentemuseum, The Hague. Page 116: National Gallery, London. Page 117: John Webb/Tate Gallery.

Cover: Narodni Gallerie, Prague

Picture Research: Penny J. Warn.

Index